Playful Painting

PETS

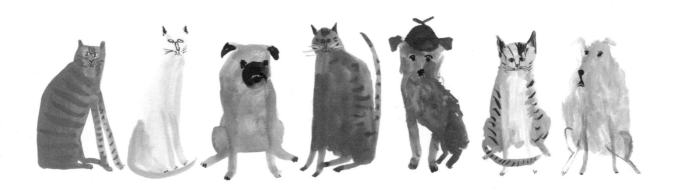

MORE THAN 20 fun and clever projects
for animal lovers

FAYE MOORHOUSE

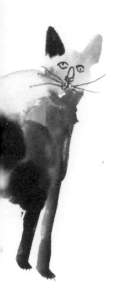

 Quarto is the authority on a wide range of topics.
Quarto educates, entertains, and enriches the lives of our readers—
enthusiasts and lovers of hands-on living.
www.quartoknows.com

© 2017 Quarto Publishing Group USA Inc.
Published by Walter Foster Publishing,
an imprint of The Quarto Group
All rights reserved. Walter Foster is a registered trademark.

Artwork and photographs © 2017 Faye Moorhouse

Cover Design & Page Layout: Krista Joy Johnson

6 Orchard Road, Suite 100
Lake Forest, CA 92630
quartoknows.com

Visit our blogs at quartoknows.com

Printed in China
10 9 8 7 6 5 4 3 2 1

 MIX
Paper from
responsible sources
FSC® C016973

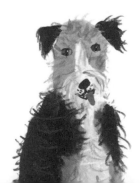

Playful Painting

PETS

MORE THAN 20 fun and clever projects
for animal lovers

TABLE OF CONTENTS

INTRODUCTION	6
TOOLS & MATERIALS	8
PAINTING & DRAWING TIPS & TECHNIQUES	10
COLOR THEORY BASICS	16

Dopey Dogs 19

Yellow Lab in Socks	20
Funny-Looking Frenchie	24
Wiener Dog on Wheels	28
Pug in a Hat	32
Pullover-Wearing Pit Bull	36
Scruffy Terrier	40
Snazzy German Shepherd	44
Barely Behaved Beagle	48
Gallery	52
Dopey Dogs Sketchbook	64

Kooky Cats 69

Scruffy Cat 70

Persian Cat in a Hat 74

Fluffy Maine Coon 78

Besweatered American Shorthair 82

Tortoiseshell Asleep on a Rug 86

Sophisticated Siamese 90

Raggedy Ragdoll 94

Gallery 98

Kooky Cats Sketchbook 110

Pick Your Pet 115

Chubby Hamster 116

Goldfish in a Bowl 118

Miniature Pig 120

Budgie Bird Buddy 122

Rascally Rabbit 124

Pick Your Pet Sketchbook 126

Fun with Papercraft Pets 131

Cat Garland 132

Miniature Pug Concertina Book 138

ABOUT THE AUTHOR 144

INTRODUCTION

Painting pets is so much fun! It allows you to capture the true character and personality of an animal in a way that simply isn't possible with photography. Even if you don't have a pet, it can still be a lot of fun to draw and paint your favorite animals. They don't even have to be pretty, as you'll see when you flip through the pages of this book. (Sorry to all the cats, dogs, and rabbits that we're offending with that statement…)

The step-by-step projects in this book will guide you through the process of painting different pets and furry friends, from a Dachshund on wheels and a sweet-but-scruffy cat to a chubby little hamster and a miniature pig. We'll walk you through the various techniques and materials you can use to create your own pet portraits as well as how to turn your paintings into decorative paper products.

Practice makes perfect, so begin by completing the projects in this book, and then take your newfound skills out into the wild and paint or draw on the sketchbook pages that we've included. Ask your pets to strike a pose, and let's start painting!

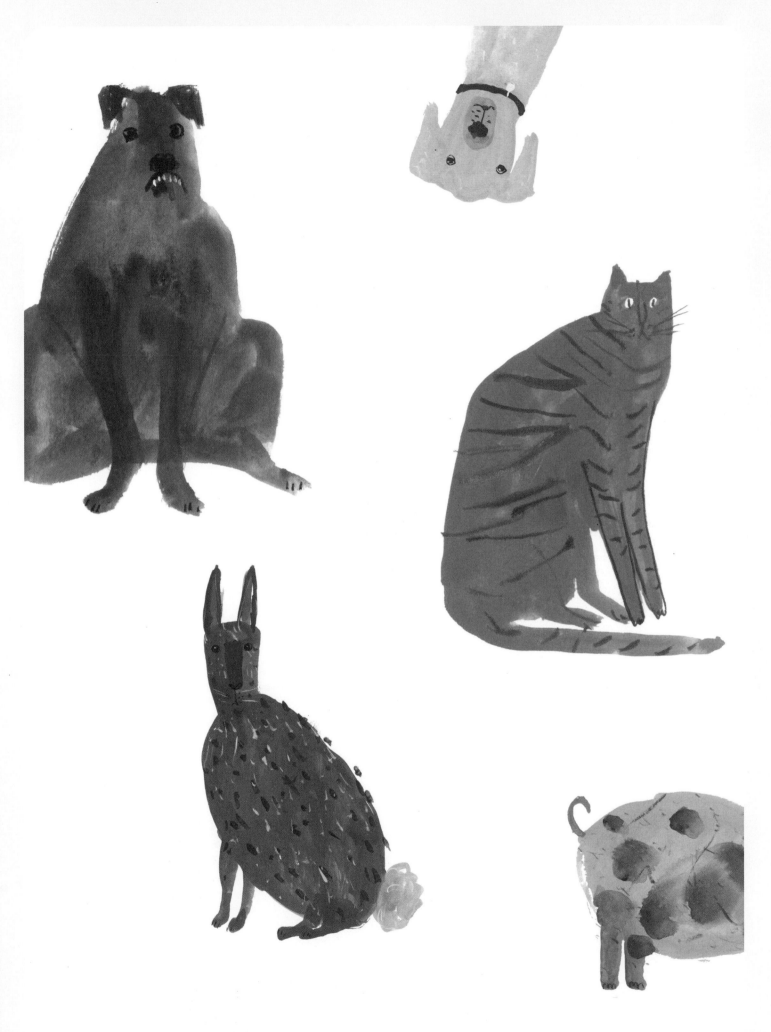

TOOLS & MATERIALS

I use just a few affordable, accessible tools and materials to paint portraits of various household pets, from cats and dogs to goldfish, rabbits, and more. Here are some of my favorite items.

SURFACES

I like painting on heavyweight drawing paper that's absorbent, has a slight texture, and allows my paint colors to look muddy. I experimented with lots of different kinds of paper before discovering my favorite, so I recommend trying various types until you find one that you like.

GOUACHE

My favorite paint to use, gouache has slightly more body, provides better coverage than watercolor, and has a nice matte finish. It's also super easy to use. I prefer the kind that comes in small jars, but gouache is also available in tubes.

You can find cheap to expensive gouache paints at many art-supply stores. I like to use a mid-range kind, but you will want to experiment and try out different brands and types to find your favorite paint.

After experimenting with a certain type of paper, write on the back what type of paper it is and where you found it. Store all of your experiments together in a drawer or folder so that you can refer to them without forgetting where your favorite paper came from!

PAINTBRUSHES

I mainly work with just two paintbrushes: a very fine brush and a medium-sized brush. However, as with paint brands, experiment and find the sizes that work best for you and your painting style.

WATER

Clean water is essential when working with gouache paint. I keep mine in an old jar.

PAINT PALETTE

I've tried lots of different paint palettes. At the moment, my favorite one is an old, white dinner plate.

PAPER

Make sure you have a piece of absorbent paper, such as paper towel, on which to dab your brushes. You might also want a piece of scratch paper for testing out paint colors.

COLORED PENCILS

I like to combine the hard, broken lines that colored pencils produce with the soft, flowing ones of gouache paint. You can use watercolor pencils, but I often just use good-quality artists' colored pencils.

PAINTING & DRAWING TIPS & TECHNIQUES

How you use your drawing and painting tools and materials will change the way your painted pets look. Here are some of my favorite painting and drawing techniques as well as tips for creating whimsical animals.

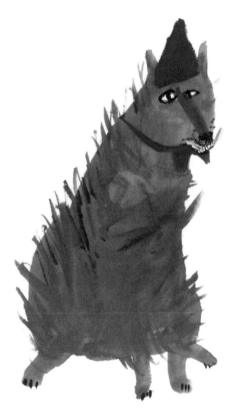

BUILDING LAYERS OF PAINT

To create a solid area of color with paint, build it up in layers rather than painting one thick layer. Two or three loose, watered-down layers of paint will give you a flat finish that's free of visible brushstrokes.

Here I have painted three layers of the same color. I let each layer dry before adding the next and created a nice, solid base color that could be used for the body of a light brown dog, cat, or hamster.

You can use a regular brush to stipple, or you can buy a special stippling brush featuring very blunt hairs.

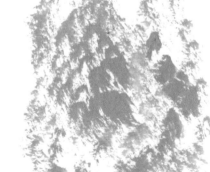

STIPPLING

Stippling can be used to build texture in a painting. For example, if you want to paint a scruffy dog, simply load a paintbrush with paint, and dab it repeatedly onto the paper to create fur.

DRYBRUSHING

Like stippling, applying paint with a dry brush can add texture to a painting.

Grab a clean, dry brush, dip it in water-free gouache paint, and apply it to the area that needs texture. Doesn't this look like the fur on a wirehaired dog?

• •

You can also layer colors using the drybrushing technique. Let each layer dry before you add the next one to ensure that you don't lose the nice, rough texture that drybrushing creates.

PALETTE-KNIFE PAINTING

In addition to using a brush to apply paint to paper, you can also use a palette knife, which will give you a much heavier color. Simply load the palette knife with paint, and spread it onto the paper as if you were icing a cake!

Water + Paint

WET-INTO-WET

This is my favorite technique to use with gouache paint—probably because it's accomplished simply by being impatient and not allowing one area of paint to dry before adding the next one.

Painting wet-into-wet can create some lovely, unexpected shapes and effects, and it's perfect for painting the soft body of a pet. It's not well-suited for adding fine details, however.

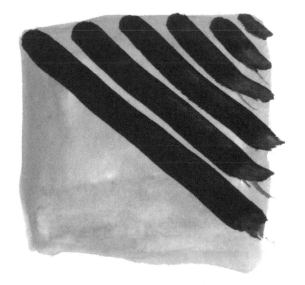

WET-ON-DRY

The wet-on-dry technique works well for creating a crisper finish and more definition between different areas of color.

· ·

Add fine details, like a dog's eyes, using the wet-on-dry technique.

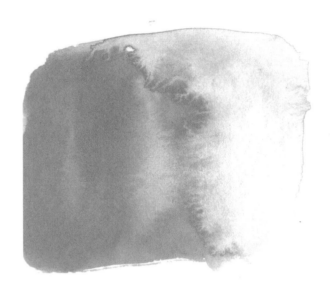

GRADIENT WASH

This easy technique creates a simple, loose tonal gradient of color. Start by laying down a really wet area of gouache paint on one end of a sheet of paper, and at the other end, while the first layer remains wet, paint another area of paint. The two areas of paint will bleed into one another, creating a lovely, loose, and natural-looking gradient.

WATERED-DOWN PAINT WASH

This effect works just the way it sounds: Simply apply very watered-down paint to paper. This technique works well for painting large areas.

• •

A very watered-down wash is not ideal for adding detail.

Pencil + Paint

Paint over colored pencil

ADDING COLORED PENCIL

Applying a wash of paint over colored pencil marks creates a subtler finish than if you apply pencil on top of paint. However, adding colored pencil over a dry layer of paint gives you a more detailed and textured area, which works well if you're drawing a dog's face or a cat's fur. Adding colored pencil on top of a layer of wet paint creates a softer, less vivid effect.

Pencil on wet paint

Pencil on dry paint

GRADIENT

To form a gradient using colored pencil, you must work in layers. Begin by lightly shading an area with color, and then add layer after layer on top. Apply the same amount of pressure on the pencil, but add more layers to the side that should appear darker. This will create a lovely, soft gradient of color.

SHADING
Colored pencils can create many different effects. One of the simplest techniques is shading. Apply even pressure and move the pencil back and forth to create a consistent color base.

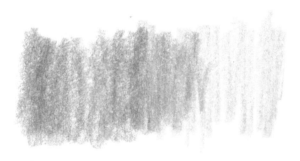

BLENDING PENCIL COLORS
You can blend two colors in much the same way as you would create a gradient. Shade each color side by side, and then add layers of color on top of each other until they look well-blended.

PRESSURE
Pushing down on a colored pencil creates a darker, even, solid color. By applying a lighter touch, you can create a softer color that might work well for the fur of a Poodle, for instance!

Apply heavy pressure and draw small dashes to achieve a texture that looks like scruffy fur.

COLOR THEORY BASICS

When learning about color theory, the color wheel is a good place to start. Understanding the color wheel and where colors sit in relation to each other will help you mix paint and familiarize yourself with color schemes.

Red, blue, and yellow are the three **primary colors**. These colors cannot be created by mixing any of the other colors.

Purple, green, and orange are the **secondary colors**. You can combine primary colors to create secondary ones. For example, yellow and blue combine to create green.

Tertiary colors are formed when you mix a primary and a secondary color.

Complementary colors sit on opposite sides of the color wheel. The complementary colors are:
- Red and green
- Blue and orange
- Yellow and purple

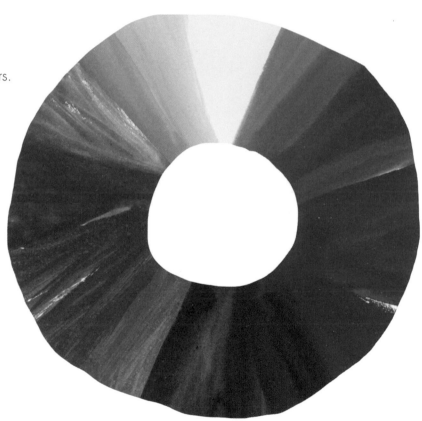

Using complementary colors together in a painting can make each color appear brighter and help your painting "pop."

Analogous colors are groups of three colors that sit next to one another on the color wheel. Examples are:
- Red, orange, and red-orange
- Blue-green, green, and yellow-green

Practice Here!

The best way to learn about color theory is by experimenting, so why not try painting your own color wheel?

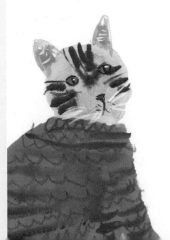

*Lighten a color by adding white to create a **tint**. Darken a color by adding black to create a **shade**.*

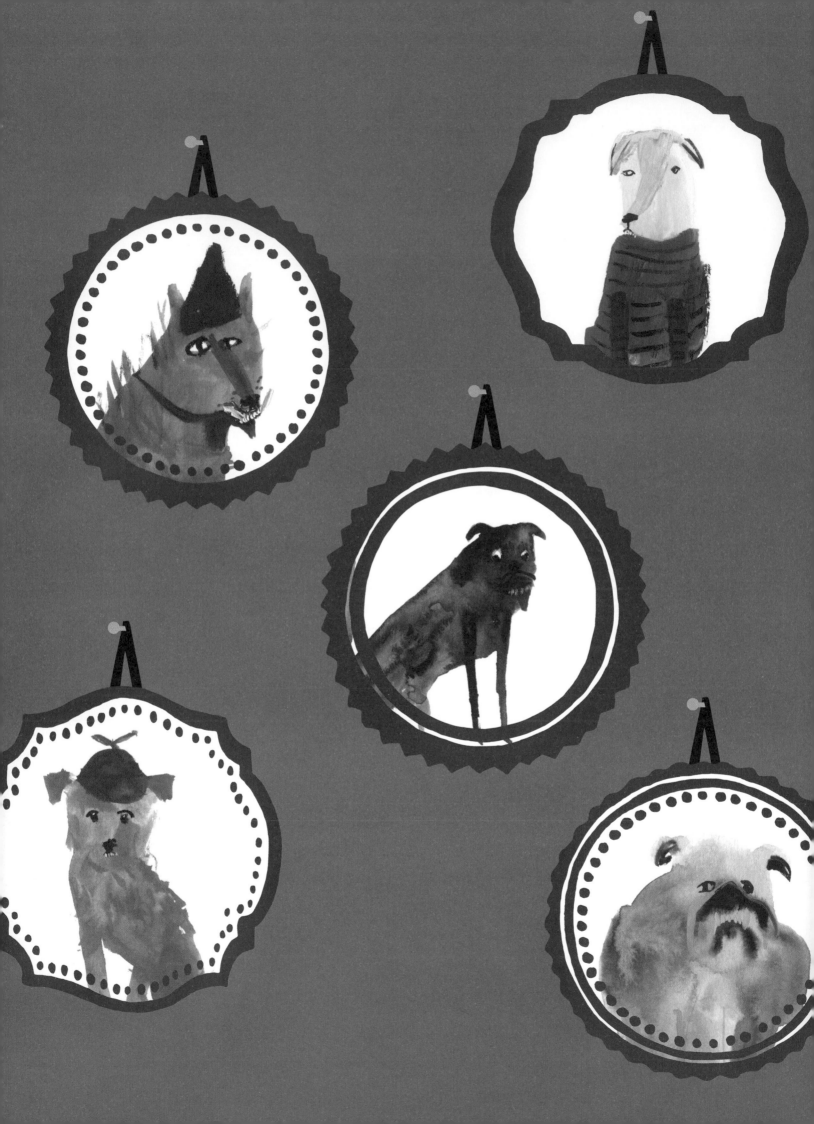

DOPEY DOGS

Yellow Lab in Socks

Labrador Retrievers have a two-layer coat, which protects them from cold, wet weather. Is your Lab more finicky than most? Despite his amazing coat, your pooch might appreciate wearing socks to keep his paws warm!

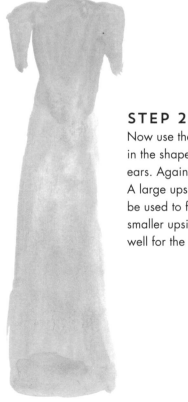

STEP 1
Begin by mixing up a pale golden color using a combination of yellow ochre and white. Use this to block in the roughly triangular shape of the dog's body.

STEP 2
Now use the same color to block in the shape of the dog's head and ears. Again, use triangular shapes. A large upside-down triangle can be used to form the head, and two smaller upside-down triangles work well for the ears.

A tall, triangular shape will work well for this Lab's body.

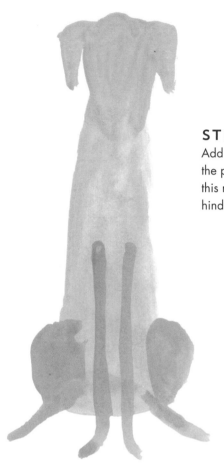

STEP 3
Add a bit more yellow ochre to darken the pale golden color, and then use this mixture to paint the dog's front and hind legs.

STEP 4
Don't forget the tail!

A dog's tail can say a lot about his mood! Feel free to add a happy, upright tail or a sad, drooping one depending on your dog's personality.

Stick with simple block shapes for now; details can be added later.

STEP 5

Once the previous coats of paint are dry, you can start to add details. Add a little squeeze of red paint to your palette, and loosen it with a touch of water. Use a medium- or fine-tipped brush to paint socks and a collar on your dog.

STEP 6

Return to the darker golden color that you used to paint the Lab's legs. If the paint is dry, add a drop of water to moisten it. Use a medium-sized brush to paint an oval shape on the dog's face.

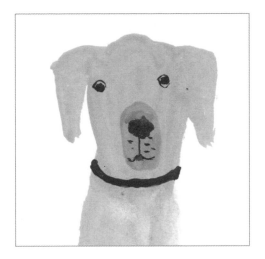

STEP 7

Apply a little bit of black paint to a fine-tipped brush, and add details to the dog's face. Paint little circles for the eyes, a bigger circle for the nose, an upside-down "T" shape for the mouth, and little dots for whiskers.

STEP 8

With a touch of white paint on a fine-tipped brush, begin adding the finishing touches, such as stripes on the socks, a little nametag on the collar, and bits of fur all over the dog's body.

When using white paint, make sure your brushes and the water that you rinse them in are clean so that the white paint will retain its vibrancy. Muddy water makes for a muddy painting!

Funny-Looking Frenchie

The French Bulldog isn't the commonest of breeds, but it could be one of the cutest! Who can resist this dog's snub nose, facial wrinkles, and vivacious personality?

STEP 1

Begin by mixing up a dark, dusty blue color. I used white, blue, and a touch of black. It may take a bit of experimentation to create the shade that you want, but that's half the fun!

Then block in the Frenchie's solid, square-shaped head using a wide brush. Don't be too precise—the messier, the better!

To create interesting colors and textures, I like to loosely mix my colors using quite a bit of water. That way, when I apply the paint to my paper, I end up with different colors and tones. The colors will bleed into each other, resulting in a nice texture that looks similar to an animal's fur.

STEP 2

While the paint is wet, add a touch more black to part of the paint mixture, and use this to add an upside-down "U" shape for the base of the dog's mouth.

Now add white to the same mixture, and paint two white blobs on the dog's head to add depth to the eyes.

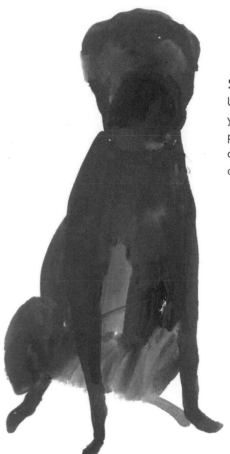

STEP 3

Use the same dark blue color that you mixed up during step 1, and paint a triangular shape for the dog's body. Also add the front and hind legs.

Frenchies tend to sit in a lop-sided way, so feel free to make the legs nice and wonky here!

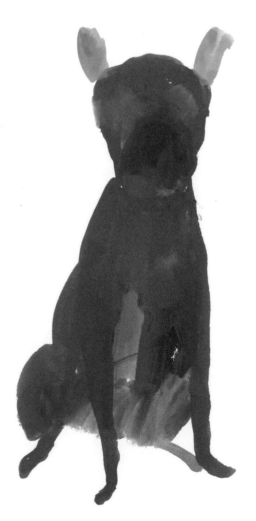

STEP 4

Mix white paint with a tiny touch of red to create a pale pink. Add two big, bold brushstrokes to the top of the dog's head. These will become the ears.

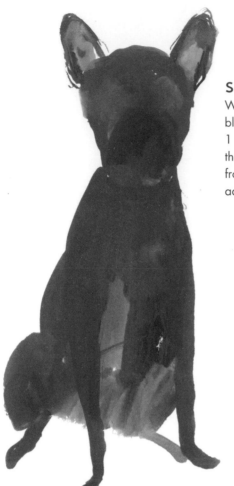

STEP 5

While the pink paint dries, use the blue paint that you mixed during step 1 and a large brush to paint around the ears. Use the darker blue mixture from step 2 and a fine-tipped brush to add loose lines around the ears.

I like to combine wide, bold brushstrokes with fine, wispy ones to add texture to my paintings.

STEP 6

Load a fine tipped-brush with black paint, and add details like the Frenchie's eyes, nose, mouth, and facial wrinkles.

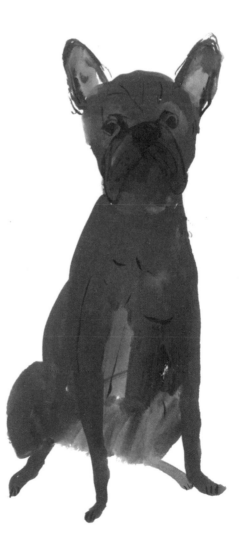

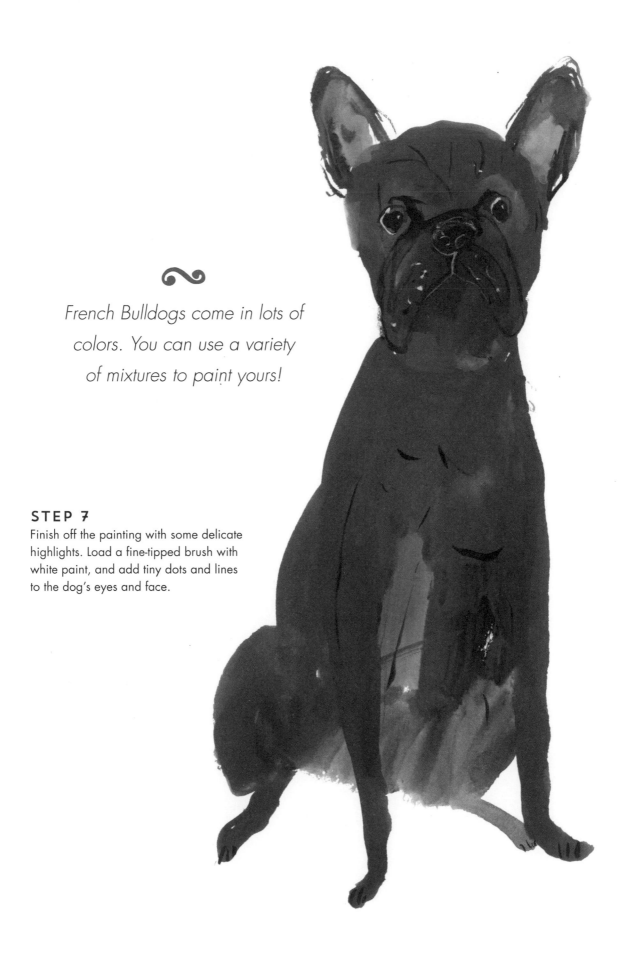

French Bulldogs come in lots of colors. You can use a variety of mixtures to paint yours!

STEP 7

Finish off the painting with some delicate highlights. Load a fine-tipped brush with white paint, and add tiny dots and lines to the dog's eyes and face.

Wiener Dog on Wheels

Dachshunds go by many names, including Dachsie/Doxie, hot dog, sausage dog, and, of course, wiener dog. Whatever they're called, their popularity, cuteness, and liveliness aren't in question. This little guy uses wheels to get around!

STEP 1
You'll paint this cute little dog using burnt umber, so squeeze a little of that onto your palette, and add a touch of water to loosen the paint slightly.

Using a fine-tipped brush, paint a loose outline of the dog's head.

STEP 2
Now add the long, sausage-shaped body using a larger brush.

I like to avoid mixing the paint on my palette too thoroughly; the uneven texture created by a mixture of watery and thicker paint makes for a perfectly messy dog-coat texture.

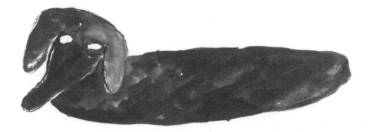

STEP 3

With the same brush, fill in the face with paint, and leave spaces for the eyes.

Consider where you want to place the eyes as well as how big they should be. Eyes add character to a portrait, so try painting a dog with his eyes close together, up high, or spaced out, and see how this changes the personality of the dog.

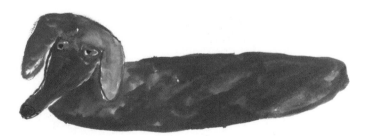

STEP 4

Let's give your dog some eyes! I like to use yellow ochre here, but you should feel free to experiment with colors.

Then, with a touch of black paint on a very fine-tipped brush, paint the pupils and the nose.

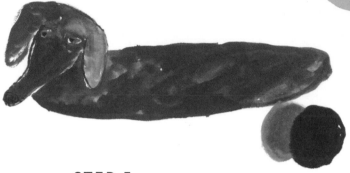

Painting the back wheel in a lighter color makes it appear farther away from the viewer.

STEP 5

To paint the wheels, mix up a dark-gray paint color, and use this to paint the back wheel. Then use black paint to add the front wheel. The two wheels should overlap.

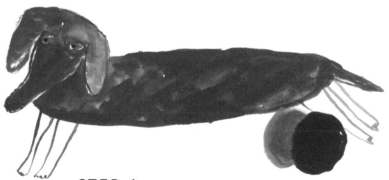

STEP 6

Using a fine-tipped brush loaded with burnt umber, outline the legs, and paint the tail. The back legs should rest on the wheels.

STEP 7

Add a harness to let the dog use his wheels! The harness doesn't have to be technically correct; in fact, the wonkier it looks, the better.

Use a fine-tipped brush and black paint to add a few lines to represent a harness. Also add details to the wheels using the dark-gray paint mixture you created earlier.

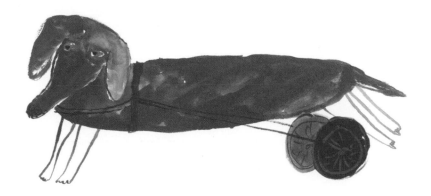

You can fill in the legs with paint if you wish, but I like to create contrast by painting both solid areas of color and fine lines within a single painting. It adds character!

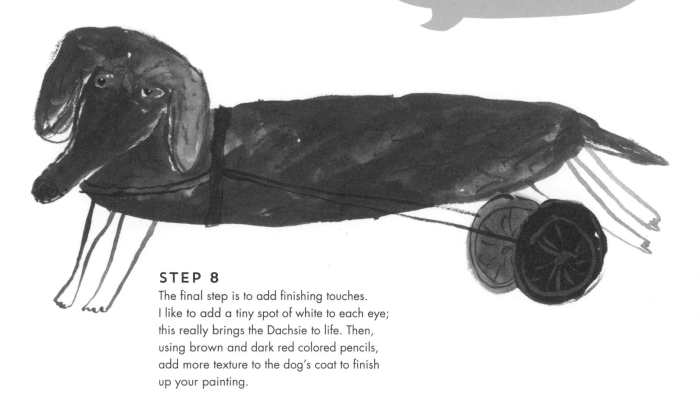

STEP 8

The final step is to add finishing touches. I like to add a tiny spot of white to each eye; this really brings the Dachsie to life. Then, using brown and dark red colored pencils, add more texture to the dog's coat to finish up your painting.

Pug in a Hat

Pugs are vivacious, fun-loving dogs that are often described as clownish, so it seems fitting that this one wears a silly-looking hat!

STEP 1

Begin by creating the base color for your Pug by mixing yellow, yellow ochre, and white. Then paint the rough shape of the dog's body.

STEP 2

Now it's time to add other details, such as the Pug's black ears, muzzle, and toes. Also add markings or different coat colors during this step. Pugs are often fawn or black, but they can have reddish or white undertones as well, and they may display dark markings.

Add details like markings and color variations while the base coat is still wet. This allows the paints to bleed into one another, creating an interesting texture.

STEP 3

Now add the hat! You can use any bright colors for your Pug's hat; I chose red, green, and blue.

Begin by painting a simple outline of the hat using a single color, and add the propeller on top.

If you make a mistake, don't start again. Mistakes add character!

STEP 4

Add your pattern of choice to the dog's hat. I chose a simple striped design, but any pattern will work here. Remember to paint the hat's visor as well.

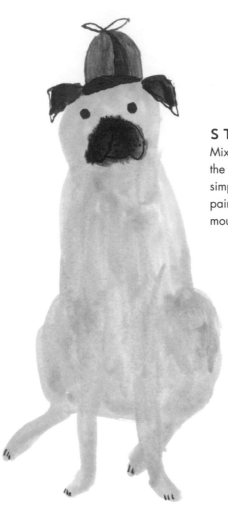

STEP 5

Mix up a nice, deep brown color for the Pug's eyes, and paint two large, simple dots on the face. Use black paint to add details for the nose, mouth, and muzzle.

STEP 6

Let the paint dry, and then add details to the eyes. The eyes will give your Pug a lot of character, so they're one of the most important elements of this portrait.

Paint a simple black circle around each eye, and then add a black pupil. Then, using a tiny bit of white paint, add highlights to the eyes.

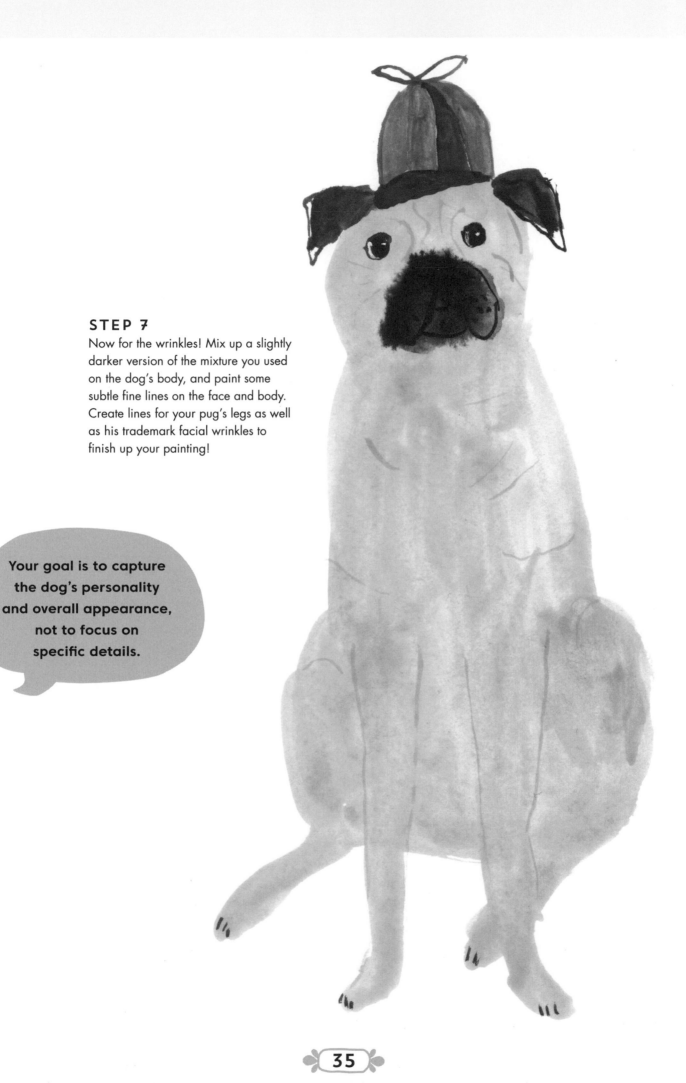

STEP 7

Now for the wrinkles! Mix up a slightly darker version of the mixture you used on the dog's body, and paint some subtle fine lines on the face and body. Create lines for your pug's legs as well as his trademark facial wrinkles to finish up your painting!

Your goal is to capture the dog's personality and overall appearance, not to focus on specific details.

Pullover-Wearing Pit Bull

Maybe you read the name of this painting project and thought, "Huh? Why would my Pit Bull wear a sweater? My dog would never put up with that!"

Well, maybe not. But that's what makes painting pet portraits so fun: You can add any accessories you like to an imaginary pet!

STEP 1
Start by painting the dog's sweater. I used turquoise, which I created by mixing blue, green, and white, but any color works!

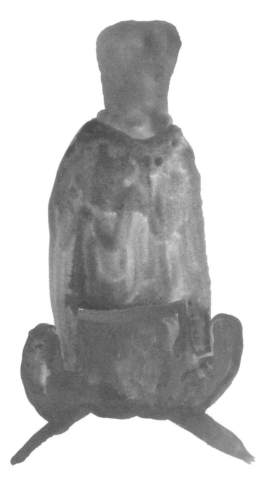

STEP 2
Now mix up a paint color to use for the dog's body. I combined yellow ochre, burnt umber, and a dash of red and used this to block in the shape of the Pit Bull's lower body, hind legs, and head. Keep this paint mixture on your palette.

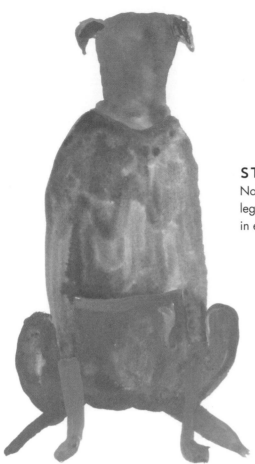

STEP 3

Now add the dog's ears and front legs. I also like to paint a spot of pink in each ear to create depth.

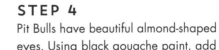

The eyes will be the darkest feature on your Pit Bull and should draw the viewer's attention to your portrait.

STEP 4

Pit Bulls have beautiful almond-shaped eyes. Using black gouache paint, add eyes and pupils to the dog's face. While the black paint is still on your brush, add lines on the dog's paws to create toes.

STEP 5

You will want to add some definition to your Pit Bull's face. Add a little more burnt umber to the brown color that's still on your palette, and use this darker shade to paint a subtle line around the lower half of the dog's face. Also create a nose and mouth with pink paint.

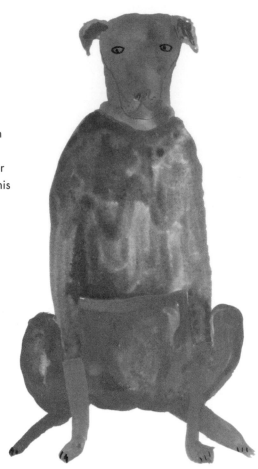

STEP 6

Now back to the sweater! Apply a bit of white gouache paint to your palette, and use this to add details, like stripes and a collar, to the dog's sweater.

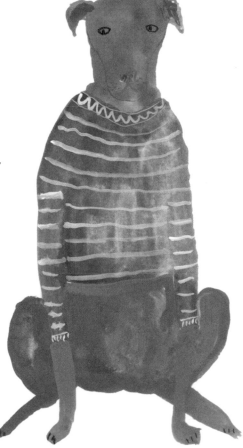

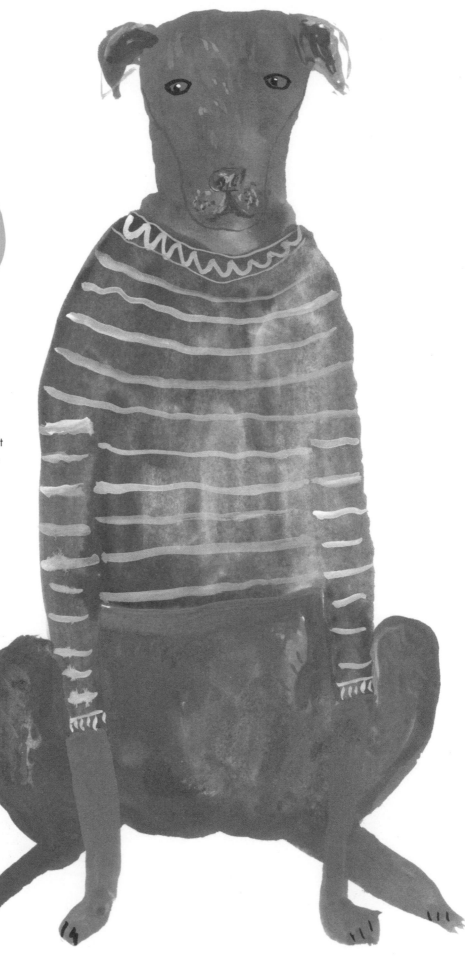

Pit Bulls have thick, short, and shiny fur. To create realistic-looking fur on your dog, add texture to the body.

STEP 7

It's time to add the finishing touches! Using some of your darker brown paint, add little dashes of fur to the Pit Bull's body and ears. Add shading to the nose and mouth, and create little white highlights in the eyes.

Scruffy Terrier

This dog looks like a mixed breed with some terrier blood in him. Use short, loose, and varied brushstrokes to create the scruff that you often see on a scrappy, scruffy terrier.

STEP 1

Begin this portrait by painting a long, loose black shape. This will form the back and side of the dog.

STEP 2

Now mix up a slightly off-white color by adding tiny dashes of black and yellow ochre to some white paint. Use this color to paint a white shape immediately next to the black one that you just created. This will form the dog's body and head. Also add another, smaller black shape on the right side of the dog's body.

Varying your brushstrokes adds interest and quirkiness to a painting.

STEP 3

Your painting may not resemble a dog yet, but this stage should change that! Use yellow ochre and medium-sized and fine-tipped brushes to add the rest of the dog's head and his legs.

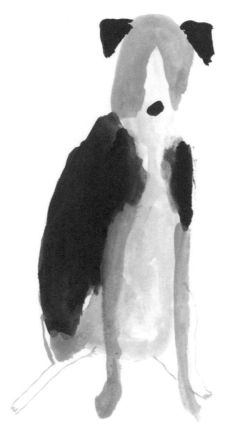

STEP 4

Now use a medium-sized brush and black paint to add a small black blob for the nose as well as two upside-down triangles for the ears.

STEP 5

Add a pink shape for the dog's tongue and two brown dots for the eyes.

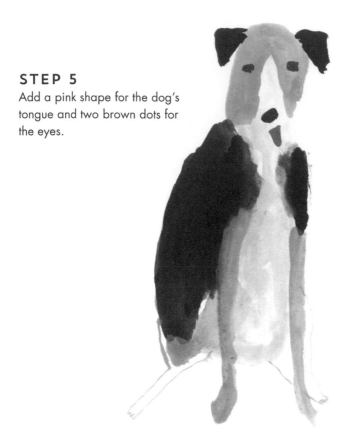

STEP 6

Next you'll need to bring your dog's face to life! Use a fine-tipped brush loaded with black paint and loose, free lines to add the mouth and eyes.

STEP 7

This dog still looks pretty neat, so let's rough him up a bit! Use a fine-tipped brush to add short, loose brushstrokes all over his body. Create a mixture of black, yellow ochre, gray, and white paints for this step.

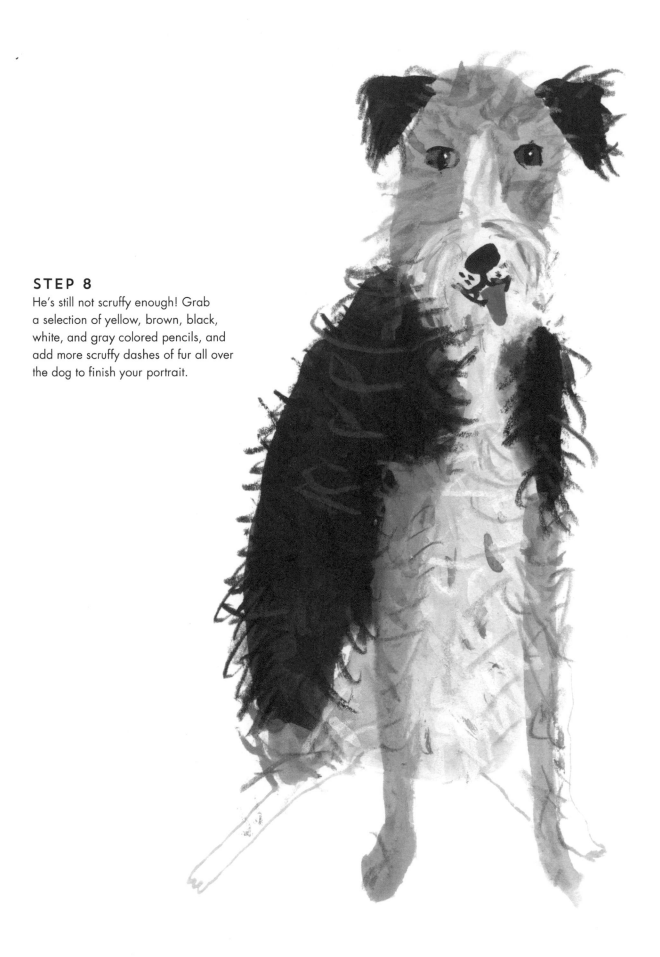

STEP 8

He's still not scruffy enough! Grab a selection of yellow, brown, black, white, and gray colored pencils, and add more scruffy dashes of fur all over the dog to finish your portrait.

Snazzy German Shepherd

German Shepherd Dogs are known for their intelligence, so it makes sense that this one wears a "smart" bow tie!

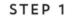

STEP 1

Create the base color of your German Shepherd using a mixture of yellow ochre and burnt umber. Load this color onto a medium-sized brush, and use it to loosely block in the shape of the dog's body.

STEP 2

While your first layer of paint remains wet, add patches of black to the sides of the dog's body and to the face.

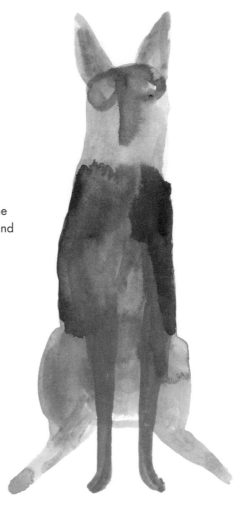

STEP 3

Mix a little more burnt umber into the base color, and paint the German Shepherd's front legs and large, pointy ears.

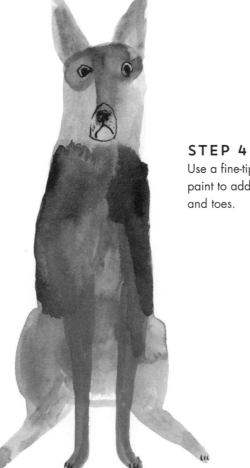

STEP 4

Use a fine-tipped brush and black paint to add the eyes, nose, mouth, and toes.

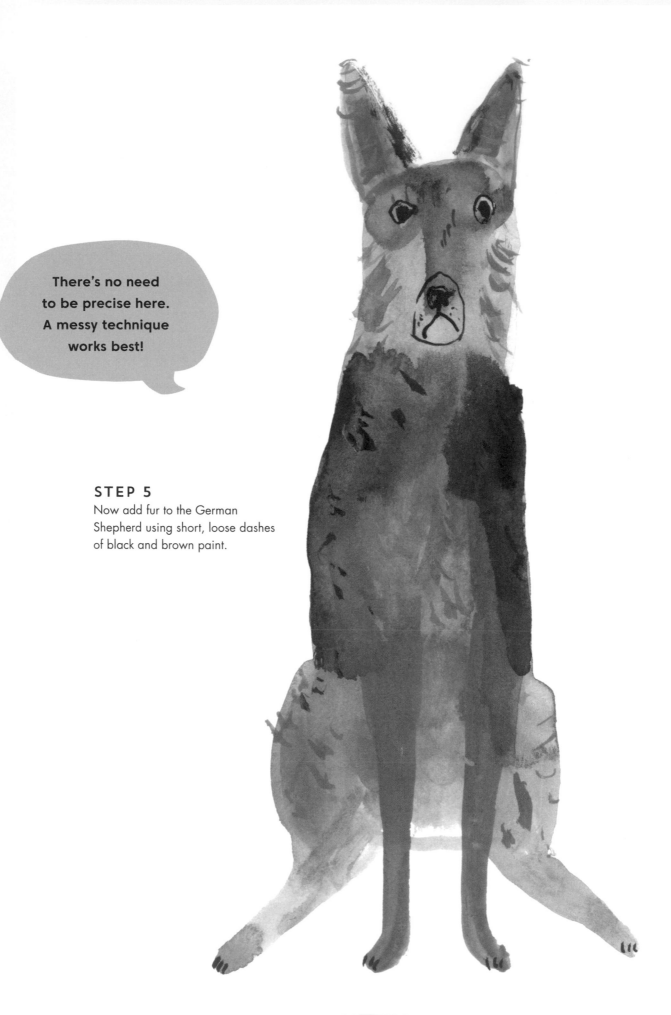

There's no need to be precise here. A messy technique works best!

STEP 5
Now add fur to the German Shepherd using short, loose dashes of black and brown paint.

STEP 6
Accessorize your German Shepherd
with a bright red bow tie using red
paint and a fine-tipped brush.

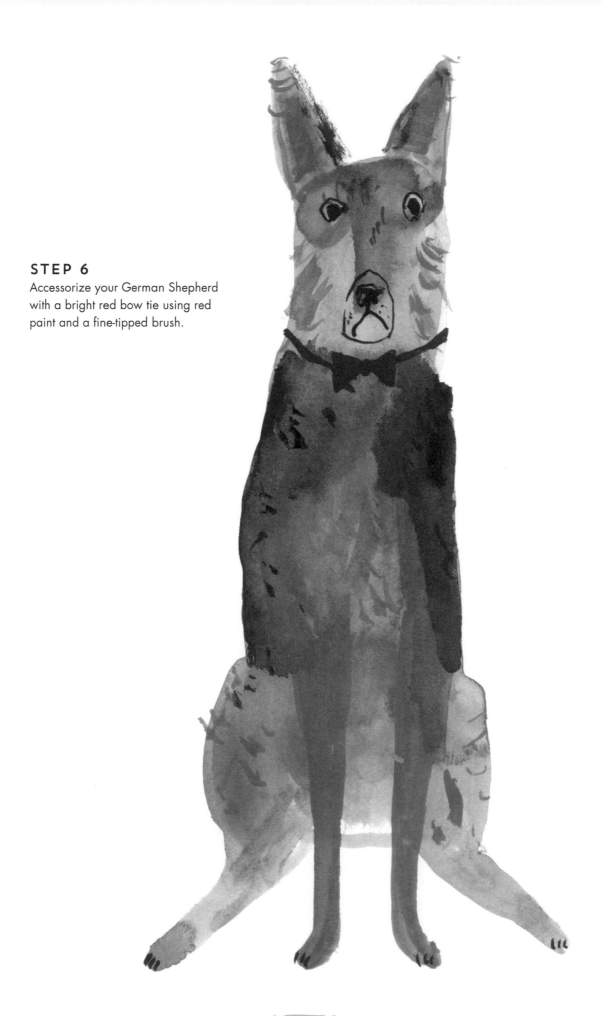

Barely Behaved Beagle

This Beagle has a sweet face that hides the fact that he's an expert escape artist, a digger, and a barker. That collar will help you track him down the next time he sniffs out something delicious and takes off after it!

STEP 1
Beagles have big, floppy ears, so let's begin by painting those! Apply a bit of yellow ochre to your palette, add a little water, and paint two ear-shaped blobs on a sheet of paper.

STEP 2
Now grab a fine-tipped brush, and use yellow ochre as well as a mixture of gray and white paints to roughly paint the outline of the Beagle.

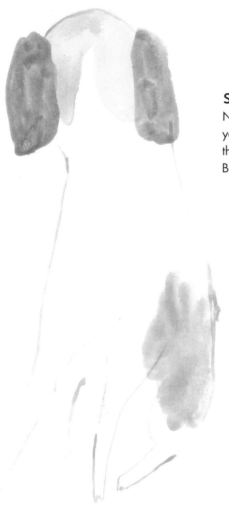

STEP 3

Now add a little more water to the yellow ochre on your palette, and use this to block in areas of color on the Beagle's face and lower body.

STEP 4

While the first layer of color remains wet, use a medium-sized brush and black paint to add a patch of black along the dog's back.

Adding another layer while the first one remains wet allows the two layers to blend.

STEP 5

Now for some details! Use a fine-tipped brush and black paint to add the dog's eyes, nose, and mouth.

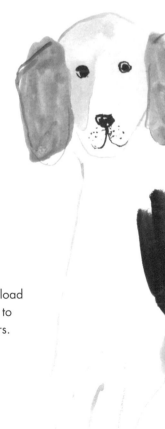

STEP 6

Clean your fine-tipped brush, and load it with a bit of gray paint. Use this to add definition to your Beagle's ears.

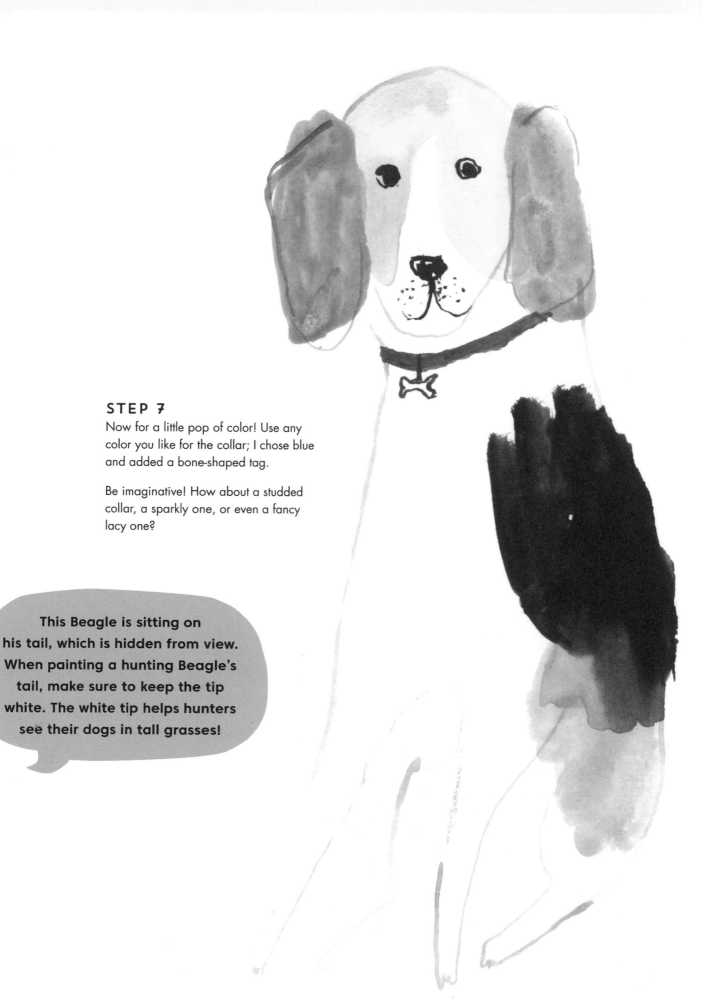

STEP 7

Now for a little pop of color! Use any color you like for the collar; I chose blue and added a bone-shaped tag.

Be imaginative! How about a studded collar, a sparkly one, or even a fancy lacy one?

This Beagle is sitting on his tail, which is hidden from view. When painting a hunting Beagle's tail, make sure to keep the tip white. The white tip helps hunters see their dogs in tall grasses!

GALLERY

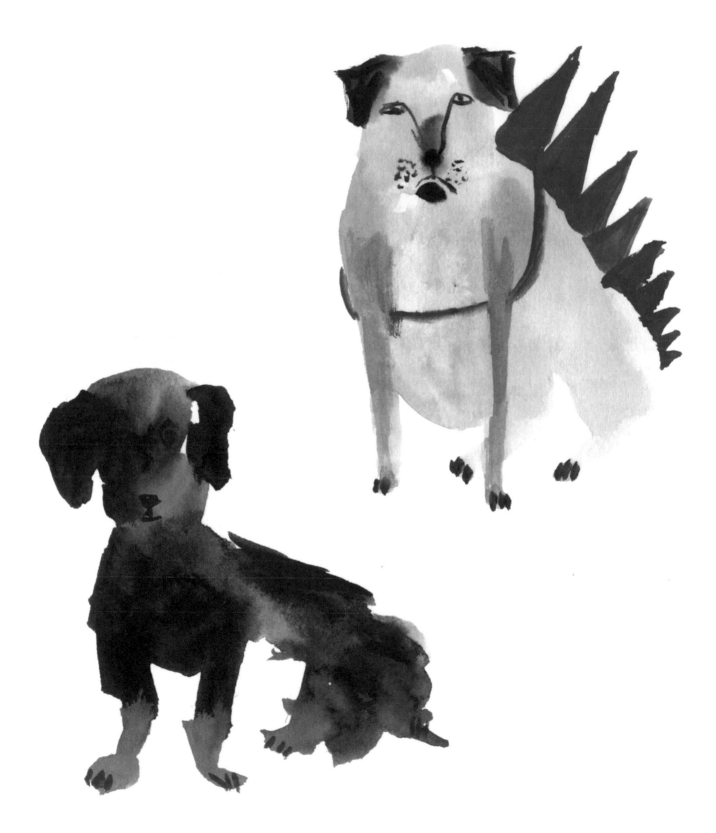

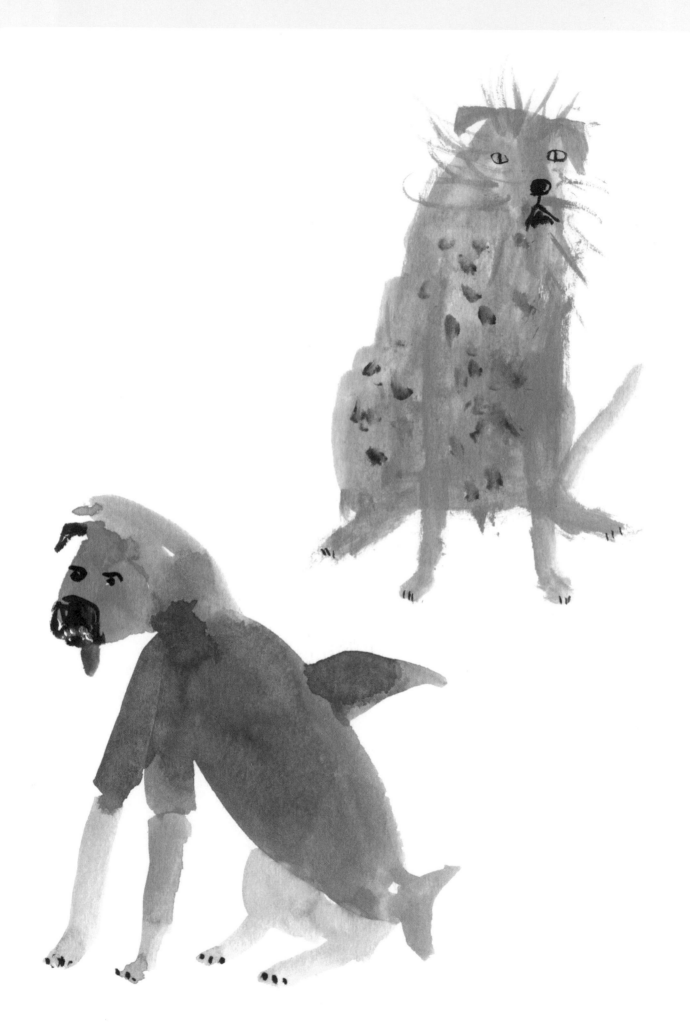

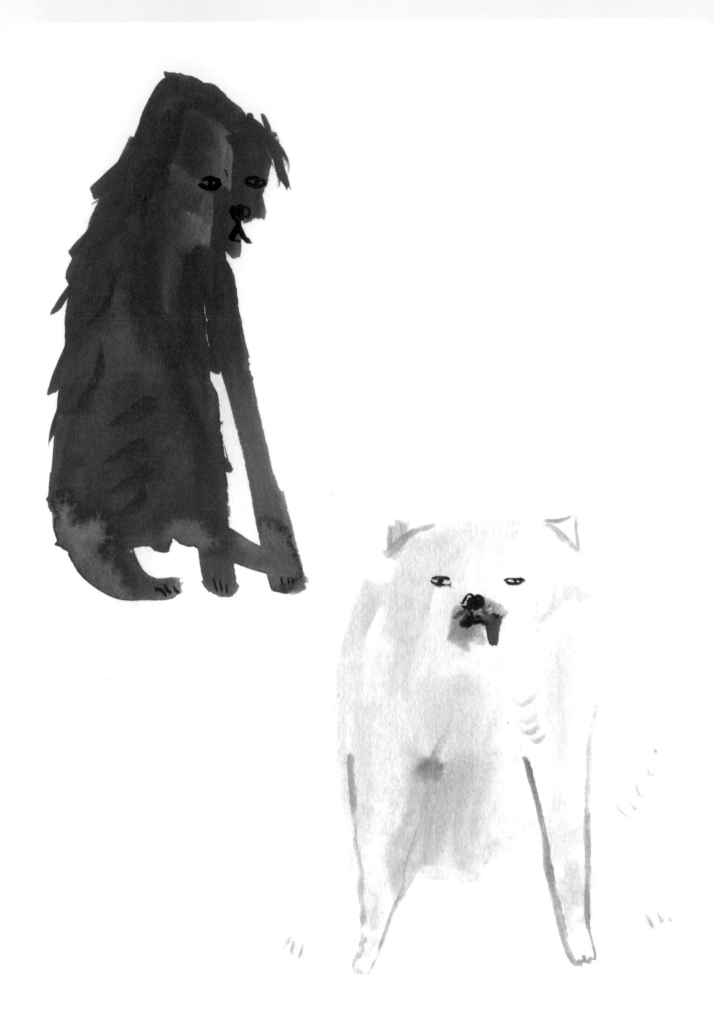

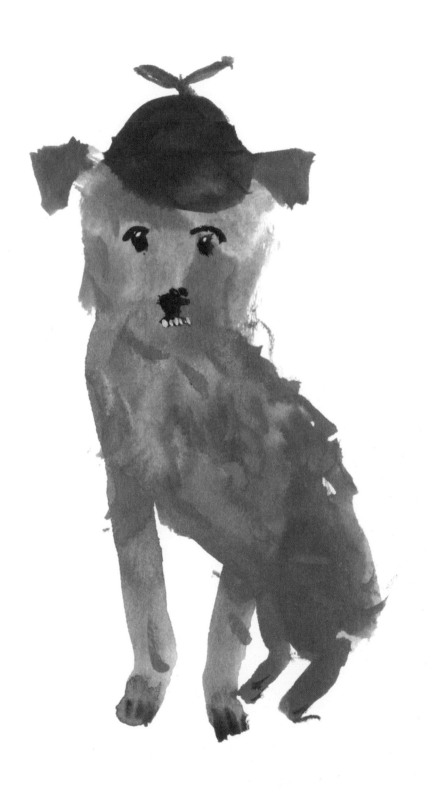

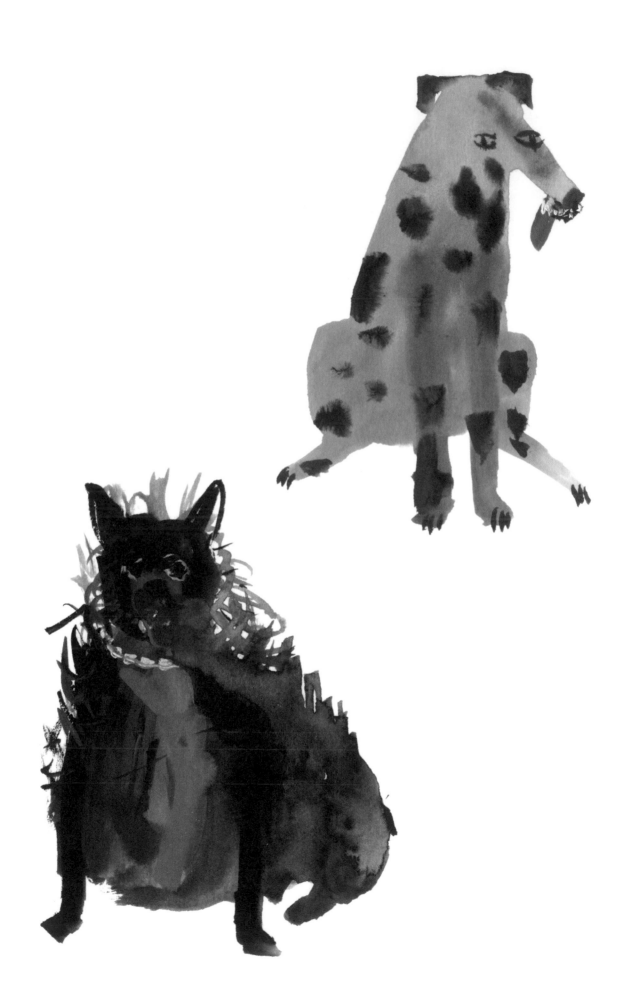

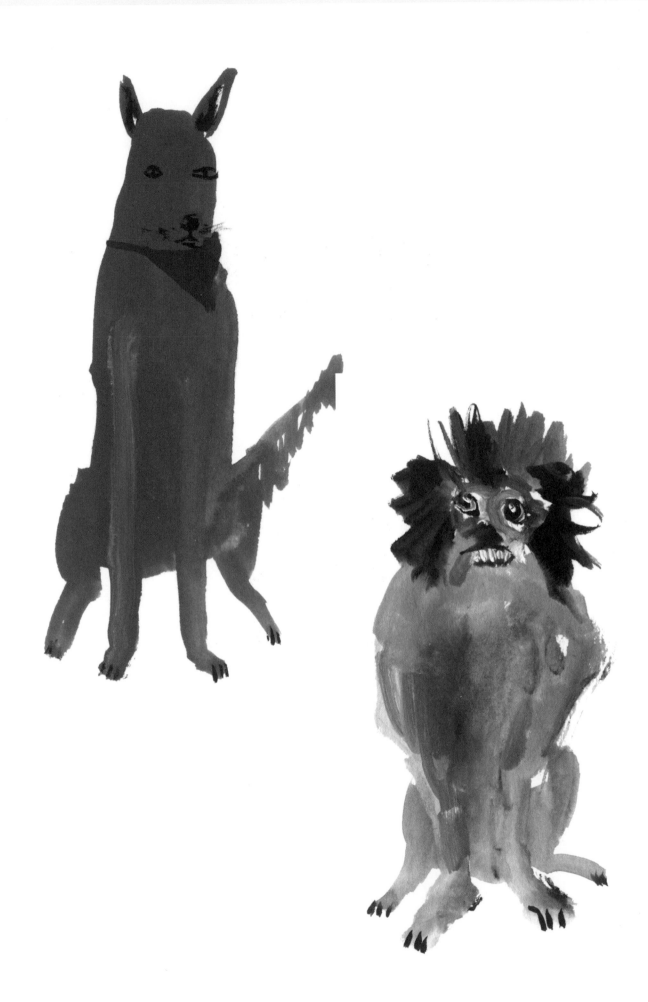

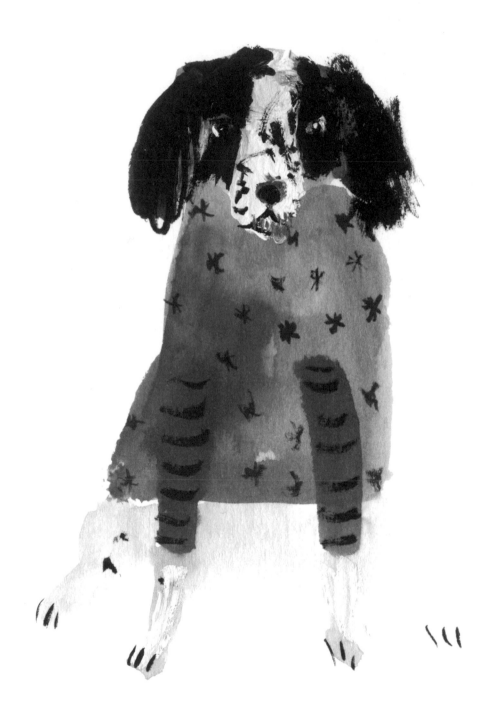

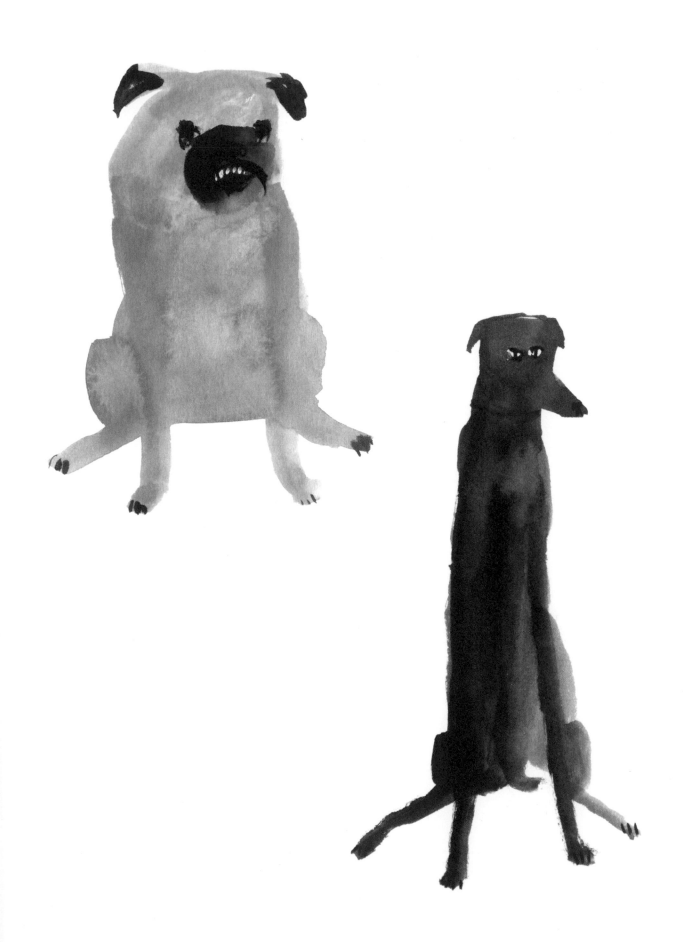

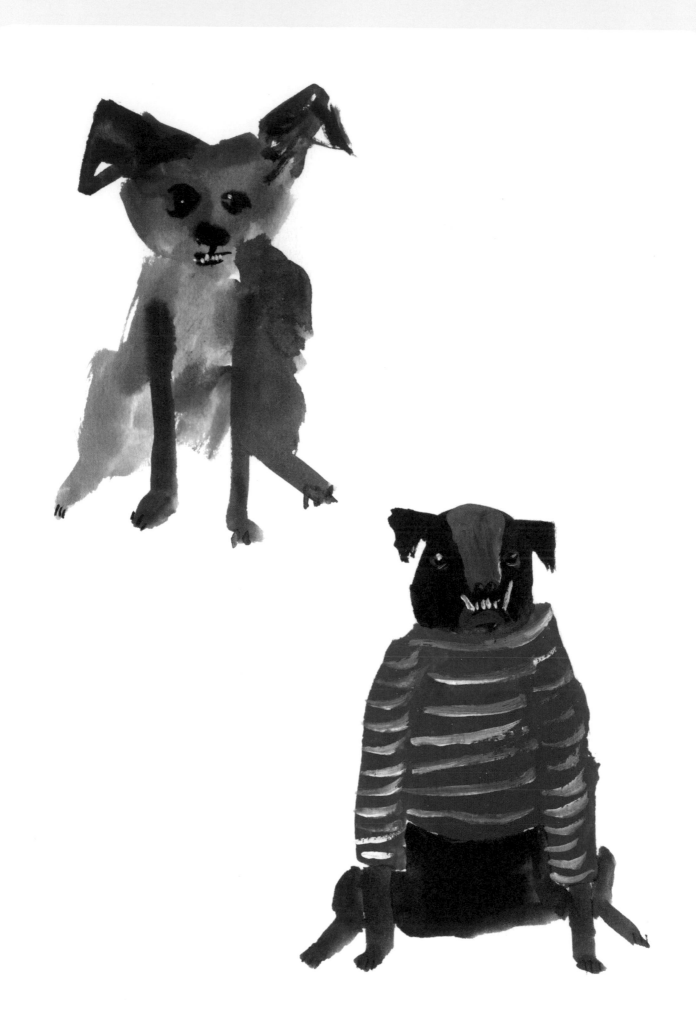

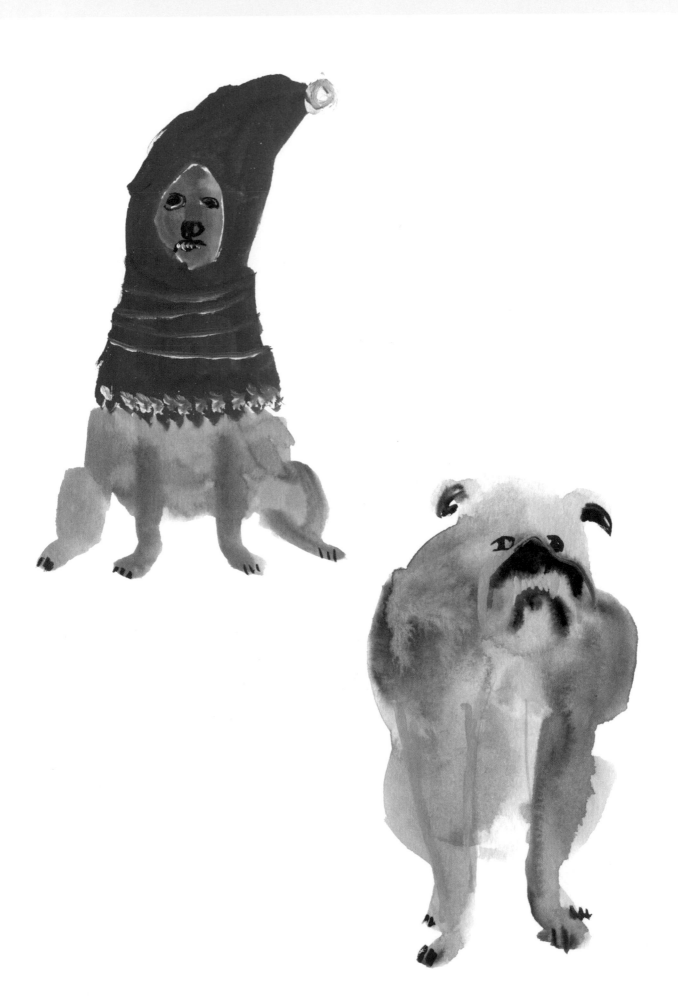

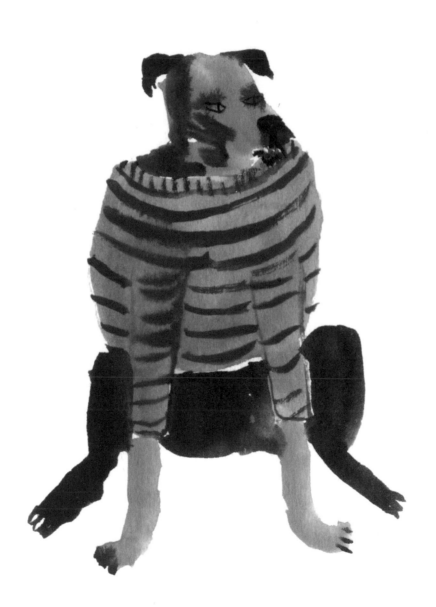

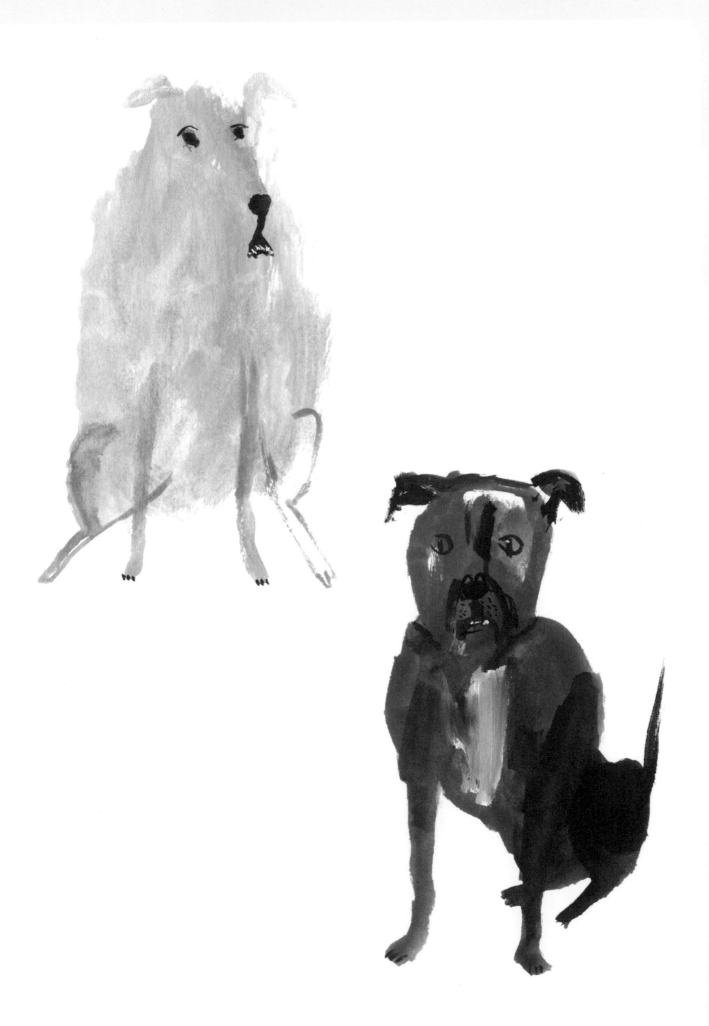

DOPEY DOGS SKETCHBOOK

Use these practice areas to paint the step-by-step projects
in this section or your own favorite dogs!

··································

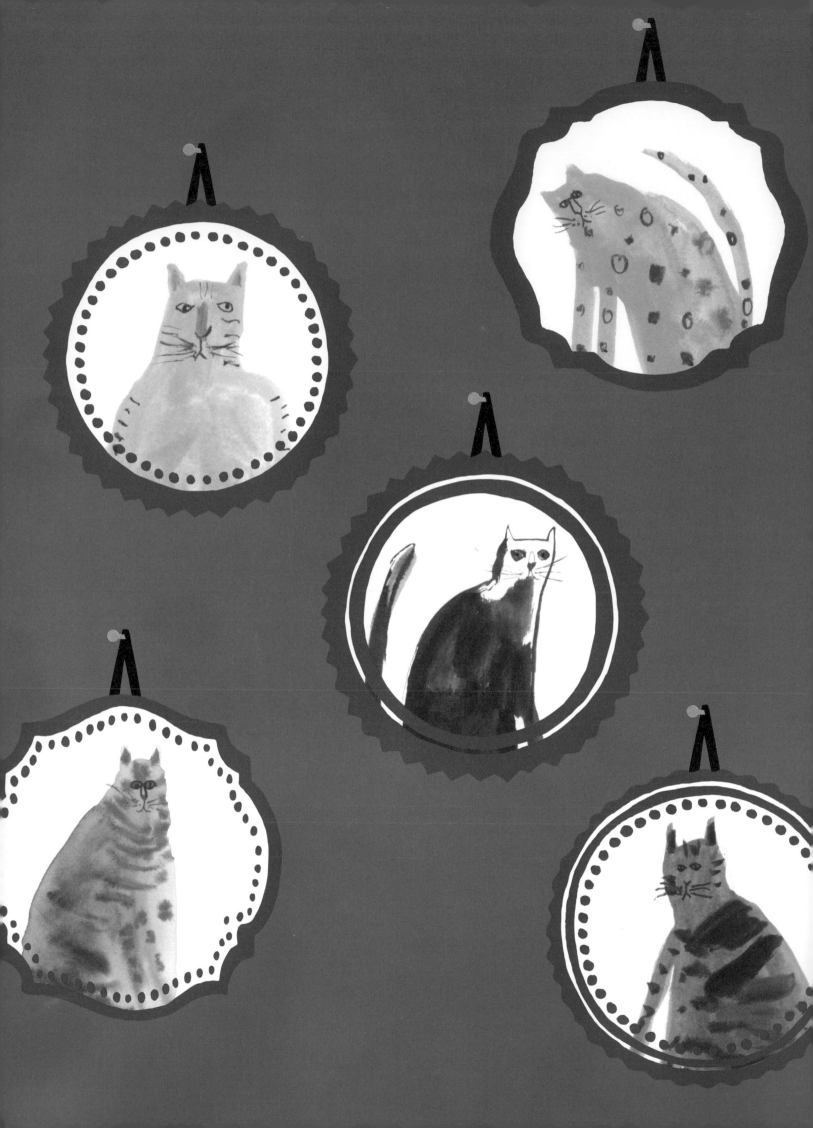

KOOKY CATS

Scruffy Cat

When beginning a new painting, make sure you have a clean palette and fresh water on hand. These are particularly useful when you're painting a pet with white fur, like this scruffy cat!

STEP 1

Squeeze a bit of white, blue, and black gouache onto your palette. Add a tiny dot of blue and black to the white paint, and thin with water to create an off-white shade.

Paint the cat's body and head. These will consist of an upside-down triangular shape with a circle on top. Then use very watered-down black paint to add the hind legs.

Make quick work of these layers while the paint remains wet so the colors can bleed into one another.

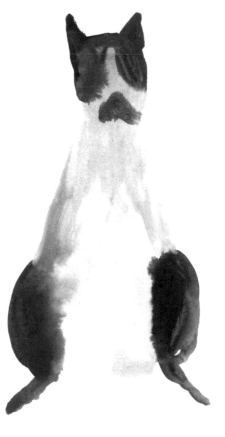

STEP 2

Use a little of the watered-down black paint to add the cat's ears and some coloring to the face.

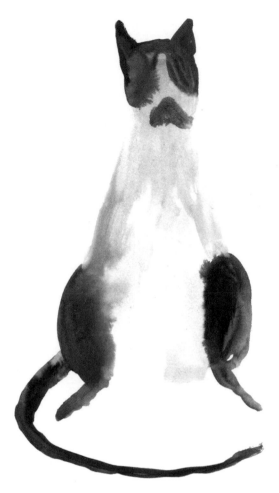

STEP 3
Don't forget the tail!

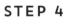

STEP 4
Add touches (just tiny, tiny amounts!) of black and blue to the off-white color you mixed up during step 1, and use this and a large brush to paint the cat's front legs.

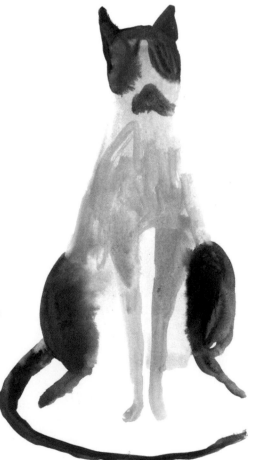

STEP 5

Using a fine-tipped brush and yellow paint, add two large dots for the cat's eyes.

Clean your brush, and then mix up a pink shade using red and white paints. Use this to add a tiny T-shaped nose.

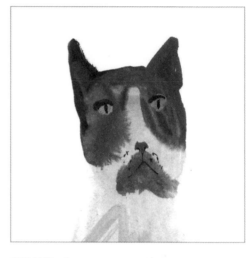

STEP 6

Load black paint onto a very fine-tipped brush, and use this to paint the cat's eyes and mouth. Don't forget little dots for the whiskers and lines for the toes!

STEP 7

With white paint and a fine-tipped brush, you can go crazy and paint lots of quick, short brushstrokes all over the cat's body and face.

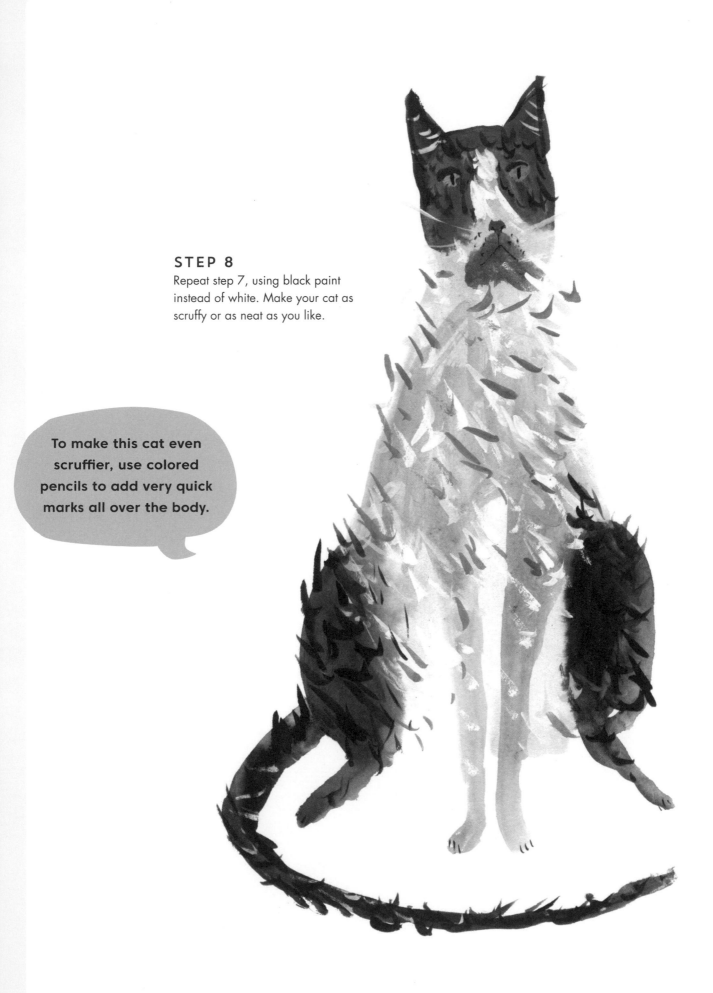

STEP 8

Repeat step 7, using black paint instead of white. Make your cat as scruffy or as neat as you like.

To make this cat even scruffier, use colored pencils to add very quick marks all over the body.

Persian Cat in a Hat

This might not be the type of hat you were expecting to see … and most cats probably wouldn't willingly wear it! It sure looks cute, though, doesn't it?

STEP 1
Apply a dollop each of blue and white paints to your palette. Add a touch of black, and mix the colors loosely to create a blue-gray hue. Now use a medium-sized brush to block in the shape of the cat's body, skipping the legs, ears, tail, and eyes.

STEP 2
Now create a bright orange color using yellow and red paints, and fill in the cat's eyes.

> By roughly mixing your paint colors, you can achieve nice gradients and different textures on your paper.

STEP 3

Using black paint and a fine-tipped brush, paint the cat's little upturned nose, mouth, and eyes.

STEP 4

Now you need to give the cat legs and a tail! Use a fine-tipped brush and the blue-gray mixture from step 1 to add these appendages.

Don't be too precise when painting this cat's features. A little unevenness adds character!

STEP 5

Squeeze a bit of burnt umber onto your palette, and block in the shape of a bear hat.

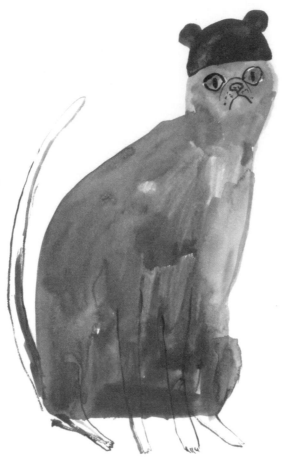

STEP 6

Add just a touch of red and black to the burnt umber already on your palette, mix well, and use this darker brown to add details to the bear hat.

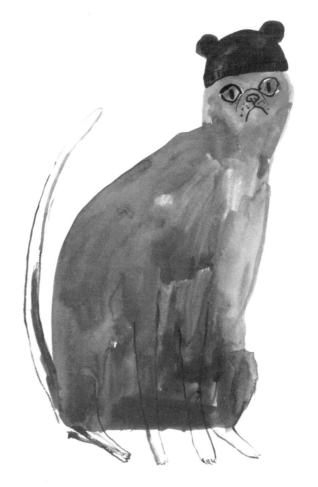

STEP 7

Use red paint to create a collar for the cat. With white paint, add whiskers and tiny highlights to the cat's eyes.

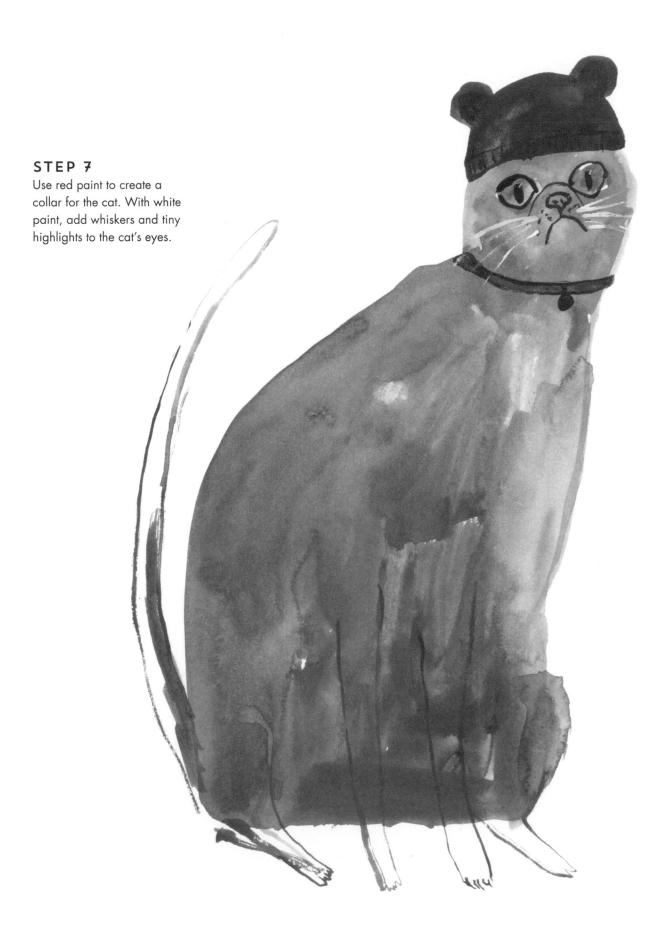

Fluffy Maine Coon

The Maine Coon is sometimes called a "gentle giant" because of the breed's large body and gentle, playful personality. When painting a Maine Coon, make sure you capture the breed's silky texture and broad chest!

STEP 1
Begin by mixing up a bright orange color consisting of yellow, red, and yellow ochre. Then use a medium-sized brush to outline the cat's body. Fill in the bottom half of the body using messy, uneven strokes. In fact, the messier, the better.

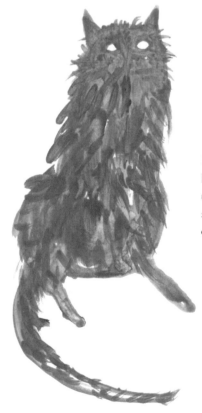

STEP 2
Now fill in the rest of the cat's body using loose, free brushstrokes. Leave small, white almond shapes for the cat's eyes, which you will fill in later.

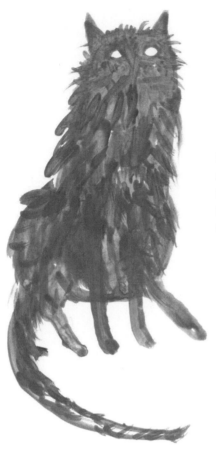

STEP 3

Add a touch more red paint to the orange color that you already mixed up, and use this to paint the cat's front legs.

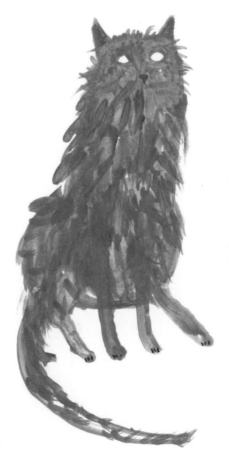

STEP 4

Now combine white and red gouache paints to create a pink hue, and use this to paint the cat's nose and inside the ears.

Add the cat's toes using a fine-tipped brush and black paint.

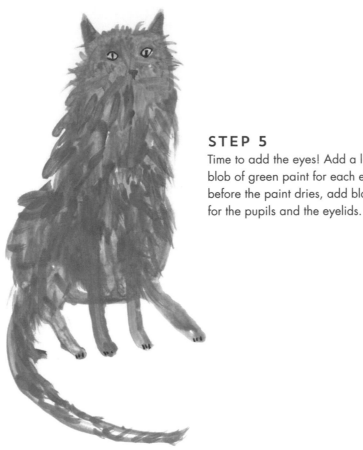

STEP 5

Time to add the eyes! Add a little blob of green paint for each eye, and before the paint dries, add black lines for the pupils and the eyelids.

STEP 6

Mix up a gray hue, and use this to add details around the cat's legs, nose, and mouth.

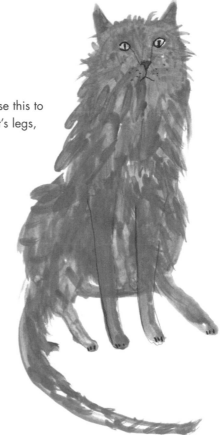

Adding certain features, like the eyes' details, while the undercoat of paint remains wet gives you less control over how the paint on top will sit. This adds an element of surprise and wonkiness to a portrait, giving it extra character.

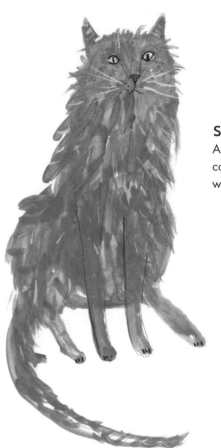

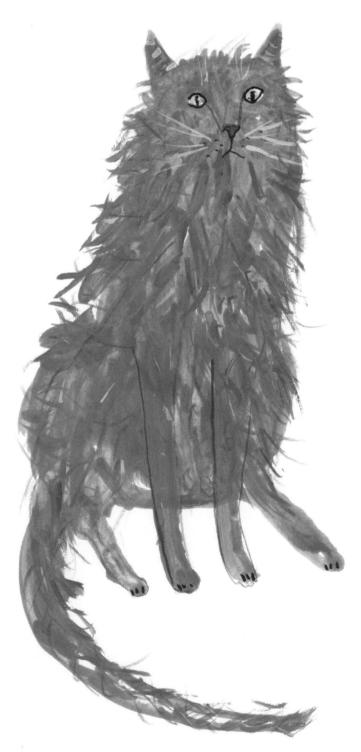

Adding white highlights when you are almost finished with your portrait can help "lift" the piece.

STEP 7
Add white highlights across the cat's coat, and use white paint to create the whiskers as well.

STEP 8
Now it's time for the finishing touches! Grab a selection of white and orange colored pencils, and add quick flicks of fur all across the cat's coat. You can also paint more tufts of orange fur to make this cat look even fluffier!

Besweatered American Shorthair

Legend has it that the American Shorthair breed was brought to North America via the *Mayflower* to hunt rats on the ship. These cats might have roughed it in 1620, but they sure like being cozy now. Give this cat a sweater to keep him nice and comfy!

STEP 1

First, mix up the color for the cat's sweater. I created mine using red, yellow, and white.

With a medium-sized brush, block in the shape of the sweater. It's essentially a blob with two long rectangles sticking out of the right side.

While the first coat remains wet, use a darker color and a fine-tipped brush to add stripes to the sweater.

STEP 2

Now add the cat! Loosely mix white, yellow ochre, and a tiny touch of black paint as well as quite a bit of water, and use this gray mixture to paint the cat's round head, body, legs, and tail.

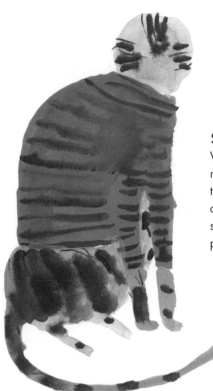

STEP 3

While the paint on the cat's body remains wet, add some markings to the fur. Load watered-down black paint onto a medium-sized brush, and paint stripes. Then use a fine-tipped brush to paint more stripes.

The combination of thick and thin brushstrokes adds depth and character to a painting.

STEP 4

Use your first paint mixture to form an upside-down capital "T" shape for the cat's nose. Then combine yellow and a tiny touch of red to create orange, and use this for the eyes. Let the paint dry.

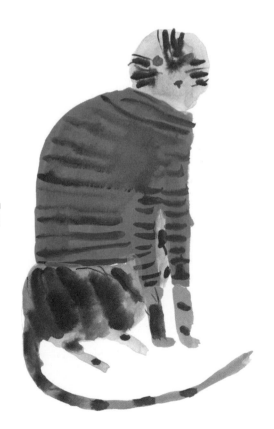

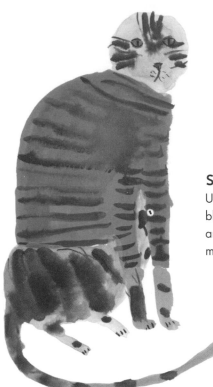

If any of your paint mixtures dry on your palette, add a few drops of water to rehydrate them. This is what I love most about gouache paint: It takes just a few drops of water to rehydrate a paint mixture that you last used days, weeks, or even months earlier!

STEP 5

Use a fine-tipped brush and black paint to add details around the cat's eyes, nose, mouth, and paws.

STEP 6

Using the same gray mixture that you created during step 2, paint two big, upside-down triangles on top of the cat's head. These will form the ears!

While the ears are wet, add a tiny spot of the lighter red paint mixture to the insides of the cat's ears to create a sense of depth.

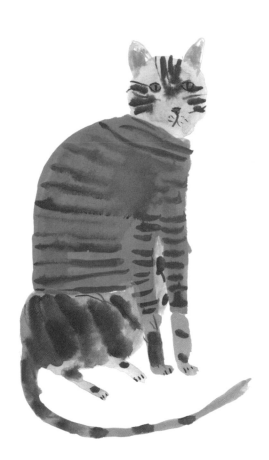

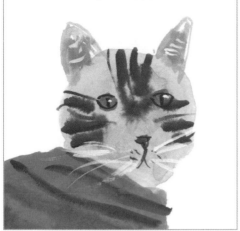

STEP 7

Use a bit of white paint and a super fine-tipped brush to add highlights, including the cat's whiskers, tiny hairs in the ears, and sparkles in the eyes.

STEP 8

Finish the portrait by adding depth and texture to the cat's sweater. With a dark pink or red colored pencil, add wavy patterns between each of the stripes.

Make sure the paint is dry before adding the pattern or you will lose the lovely, rough texture of the colored pencil.

Tortoiseshell Asleep on a Rug

What's your cat's favorite place to be? If you answered "asleep on a rug … probably where I wanted to put my feet," then you have something in common with most cat owners!

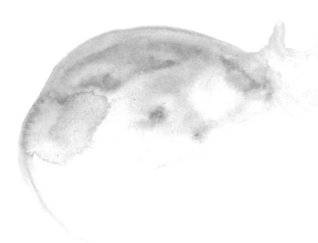

STEP 1
Create the base color for this cat using a mixture of yellow ochre and primary yellow paints. Then, with a medium-sized brush, block in the cat's body except for the legs.

STEP 2
While the yellow base coat is still wet, add black and white spots all over the cat's body.

> **Adding spots on top of wet paint will create loose, organic spots that blend well as opposed to harsh splotches of paint.**

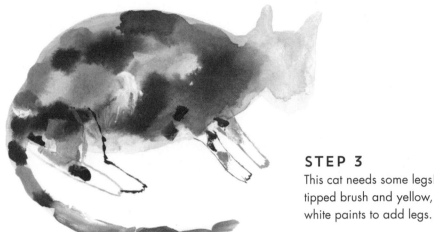

STEP 3

This cat needs some legs! Use a fine-tipped brush and yellow, black, and white paints to add legs.

STEP 4

Now for the rug! Mix up a rich red color consisting of red and just a touch of green. With a medium-sized brush, block in the oval shape of a rug underneath the cat.

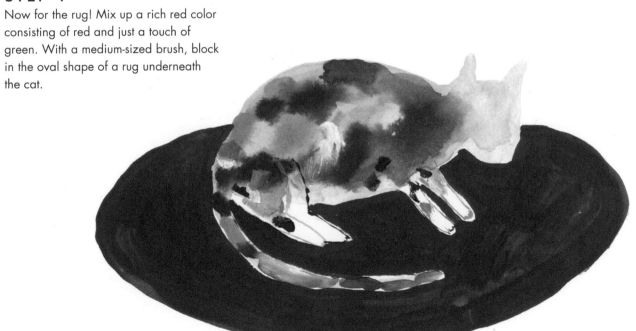

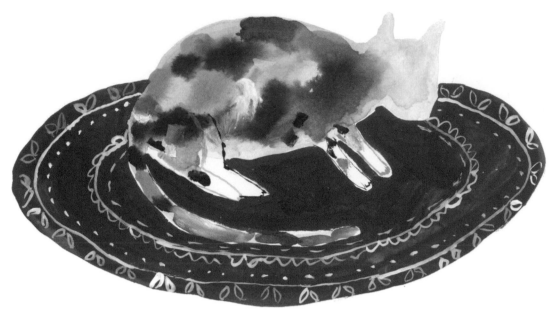

STEP 5

Use a fine-tipped brush and white paint to add a pattern (or patterns!) of your choice to the rug.

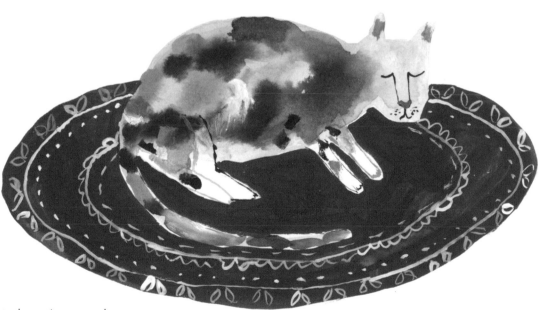

STEP 6

Add pink patches to the cat's ears and nose. Clean the brush, load it up with a bit of black paint, and use this to create details on the face.

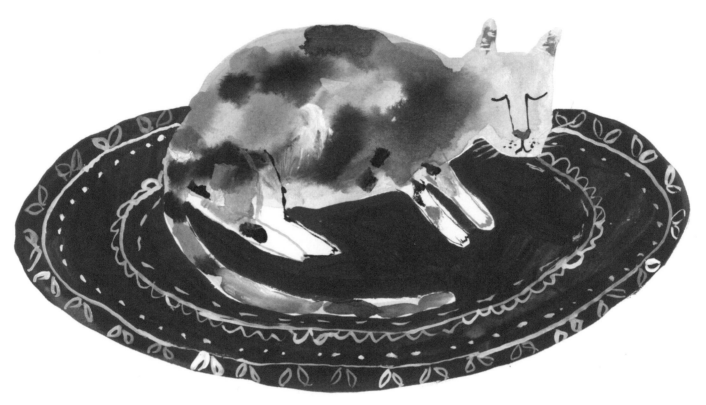

STEP 7
Don't forget the whiskers! Use quick, short strokes, white paint, and a fine-tipped brush to add whiskers to the cat's face as well as hair in the ears.

Some cultures, including the Irish and the Scottish, believe that tortoiseshell cats bring good luck. This might cheer you up the next time your tortie displays her trademark "tortitude."

Sophisticated Siamese

The Siamese cat is known for its bright blue eyes, elegant black markings, and contrasting light-colored body. Fashionable as a pet since the late 19th century, the Siamese also makes a great subject for a portrait to hang in your stylish home!

It can be difficult to paint light-colored cats and dogs, as white paint doesn't show up on white paper. To create white-colored animals, I like to use a slightly off-white color, and then add brighter details to the fur.

STEP 1

First, mix up an off-white color: Squeeze white paint onto your palette, add a few drops of water to loosen it, and then mix in tiny amounts of black and yellow ochre.

Now paint a tall, thin, bowling-pin shape on the middle of your paper.

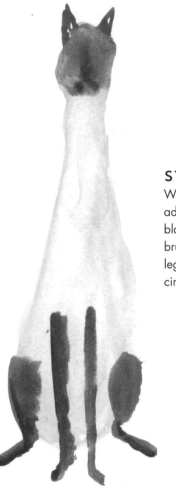

Remember: If you make a mistake, don't start again. Embrace your misplaced strokes—they add character!

STEP 2

While the base coat remains wet, add a little bit of watered-down black paint onto a medium-sized brush. Use this to create the cat's legs and ears and to add a black circle to the head.

STEP 3

Now add your Siamese's big, beautiful blue eyes. Using a fine-tipped brush and bright blue paint, add two big circles to the face.

STEP 4

With a fine-tipped brush and black paint, add definition around the cat's legs using loose, sweeping brushstrokes. Also give the cat a long, thin tail.

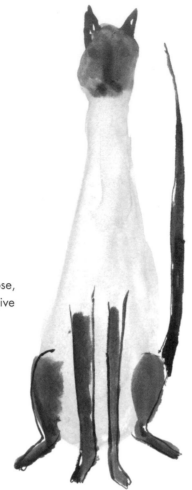

STEP 5

Reload your finest-tipped brush with black paint, and add almond shapes around the eyes, triangular shapes around the ears, and details to the face.

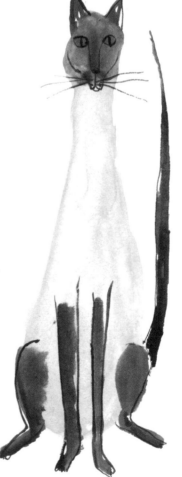

STEP 6

Finish up your painting by adding highlights. Add bright white paint to your palette, and loosen it with a drop of clean water. Then use a fine-tipped brush to add a tiny dot to each of the cat's eyes as well as loose brushstrokes all over the body to imply fur.

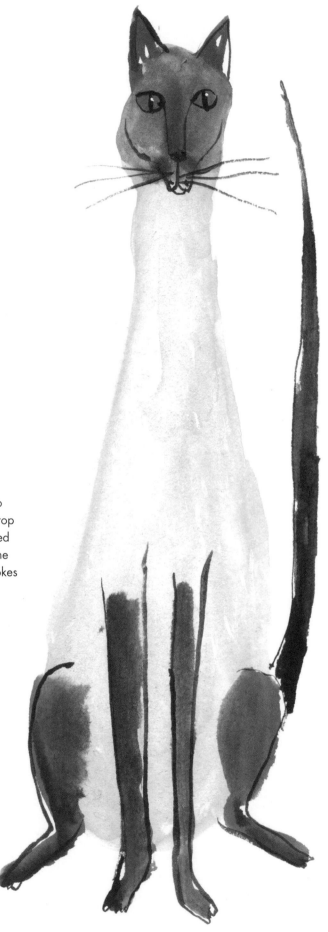

Raggedy Ragdoll

Does your Ragdoll act more like a dog? That's pretty common! In fact, Ragdolls are unusual cats in that they love to be held by anyone, will follow their owners around the house, and can be trained to perform tricks. Cool, right?

Don't mix the off-white color too thoroughly. In fact, the looser the mixture, the better. You want an inconsistent mix when the paint is applied to the paper.

STEP 1

Using bright white and tiny touches of yellow ochre and black paints, mix up an off-white color. Then use a fine-tipped brush to paint the rough outline of a fat cat. Don't add legs or a tail yet.

Add two large, blue almond shapes for the cat's eyes.

STEP 2

Grab a large brush, and load it with the same off-white color. Use a scrubbing action to fill in the cat's shape with color. You want to create a fluffy, messy, furlike texture.

Don't scrub too hard or you risk damaging your brush.

STEP 3

While the paint remains wet, use a medium-sized brush and rich brown paint (you can mix yellow ochre and burnt umber to create this) to paint an upside-down serving-spoon shape on the cat's face.

Also paint the cat's two front legs and tail. Then use a fine-tipped brush to outline the cat's back legs.

STEP 4

Squeeze a touch of black paint onto your palette, and add a little water to loosen it. Using this paint and a very fine-tipped brush, paint the cat's eyes, nose, mouth, and claws.

STEP 5

With bright white paint, add two tiny dots to the cat's eyes as well as long whiskers.

Now you need fluff...lots and lots of fluff! Using a medium-sized brush and quick, loose strokes, add white and brown paint all over the Ragdoll's body. The cat should look very fluffy when you're done!

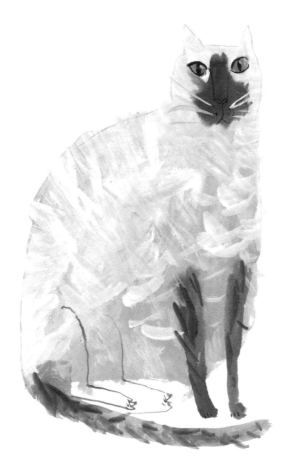

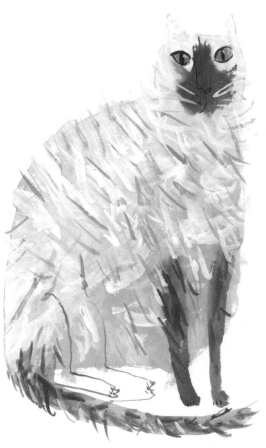

> A mixture of large and small brushstrokes adds depth to a cat's fur.

STEP 6

Now use a fine-tipped brush and off-white and brown paints to add even more fur.

STEP 7

Use a white colored pencil and short, sharp marks to add even more fur all over the cat's body to finish up this portrait!

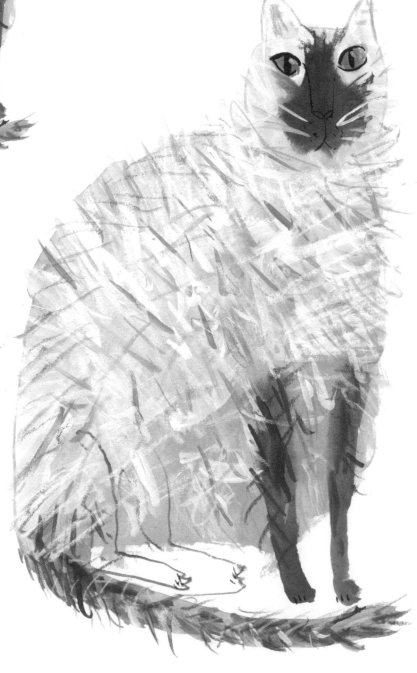

GALLERY

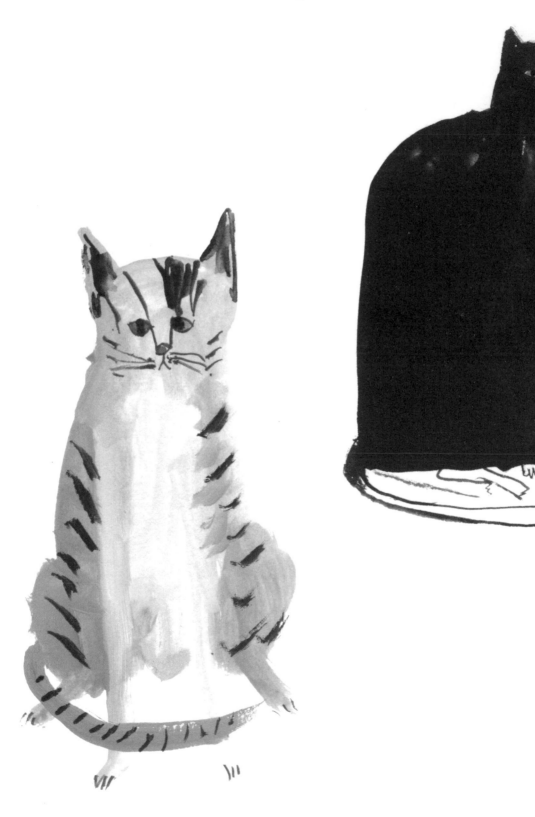

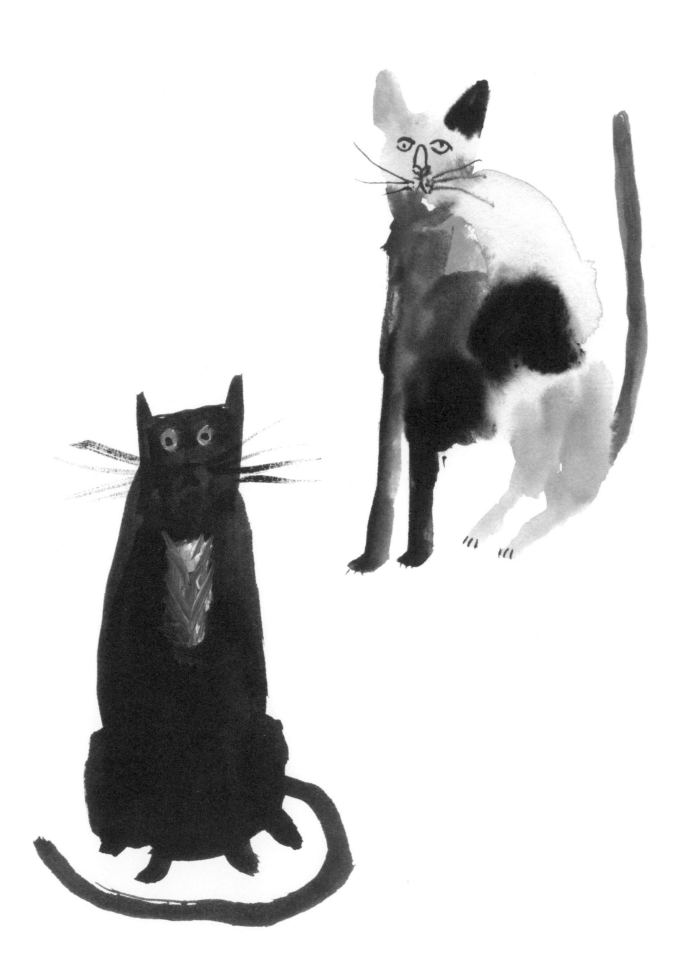

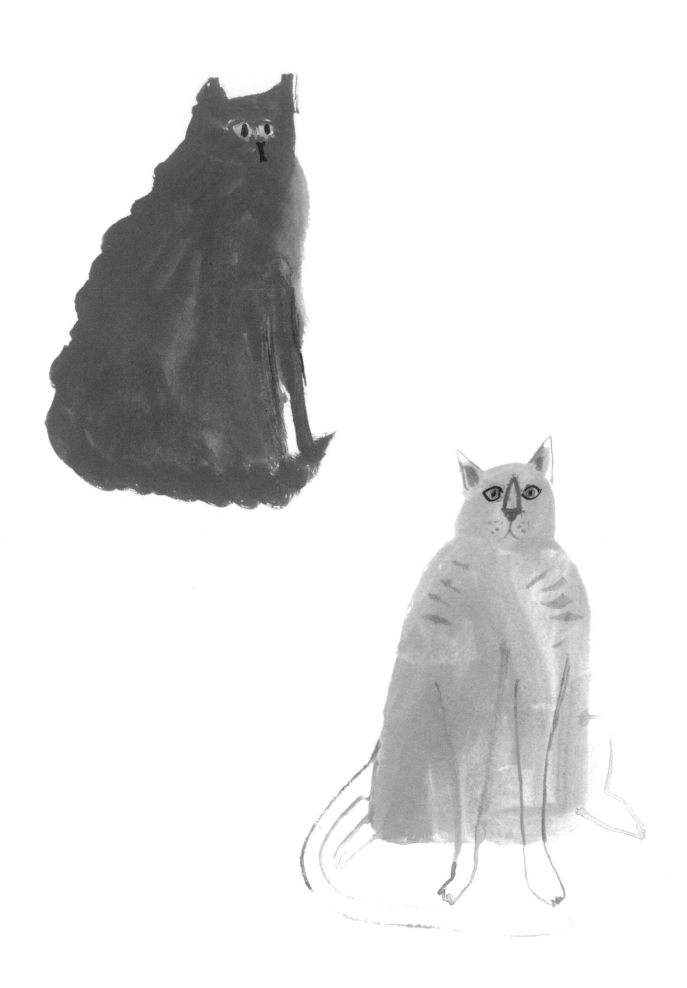

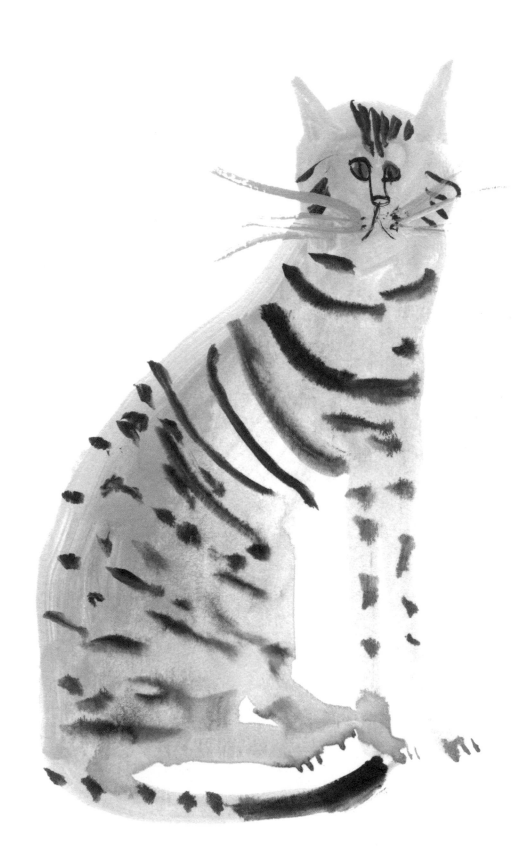

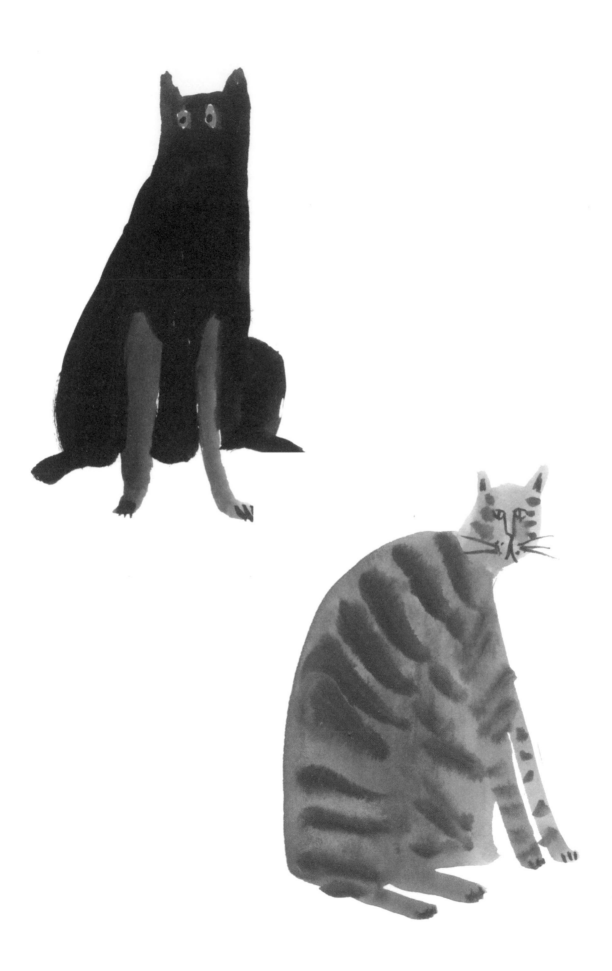

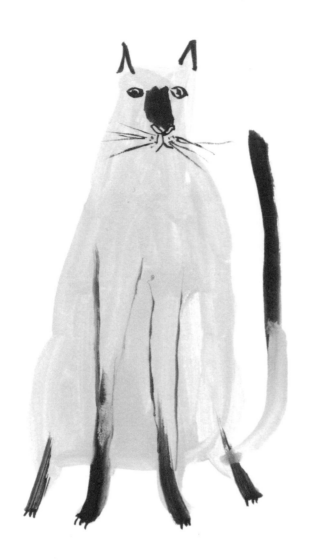

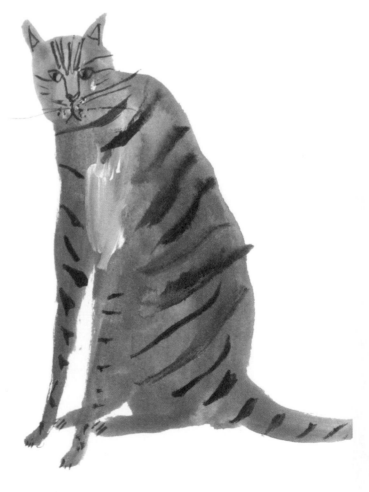

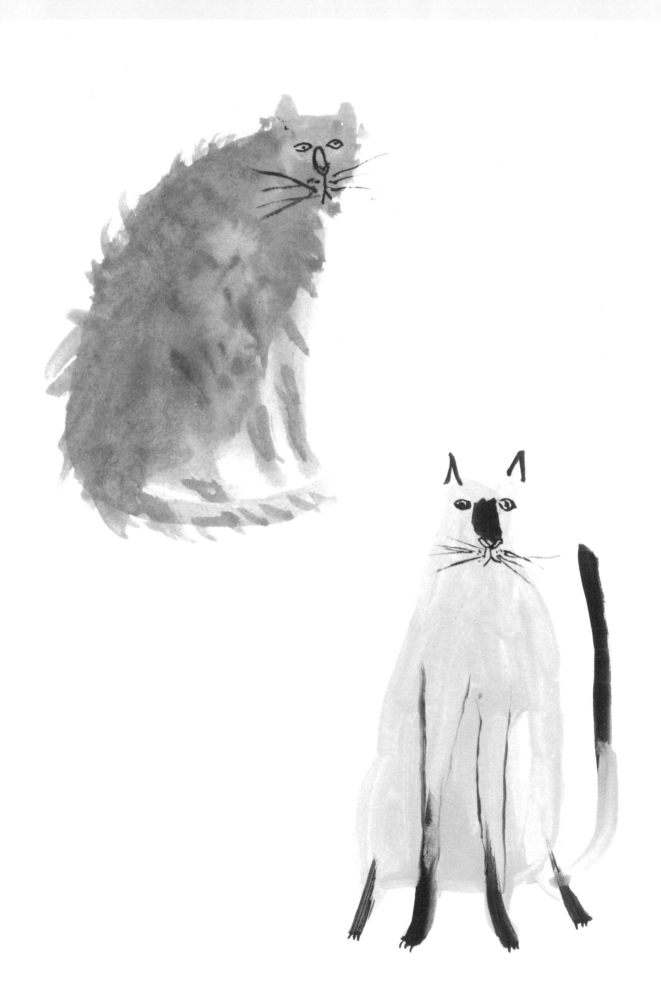

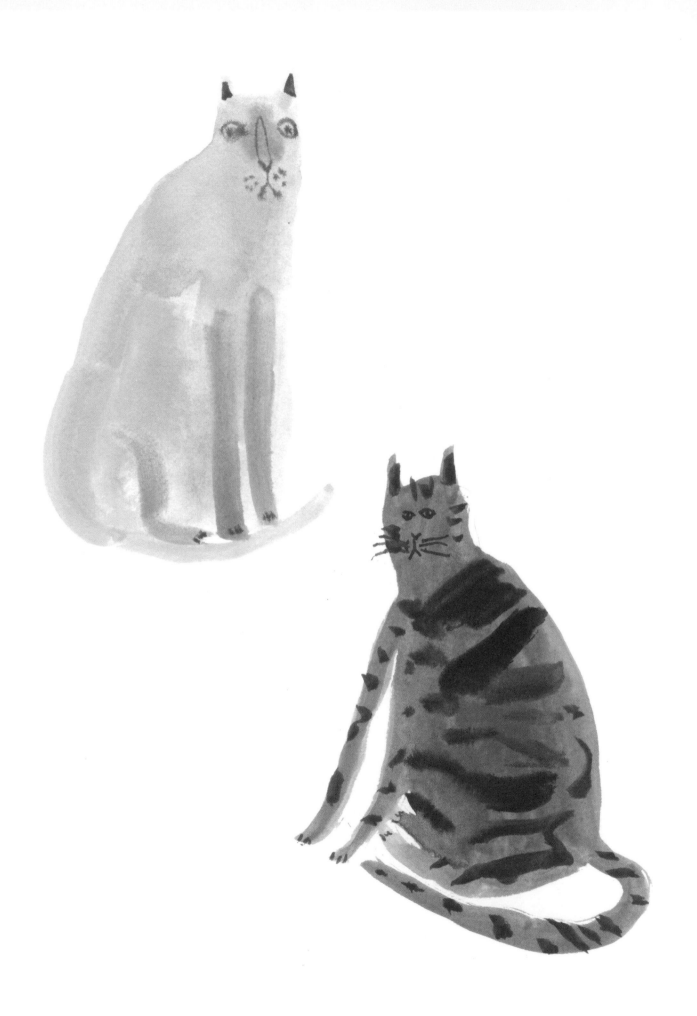

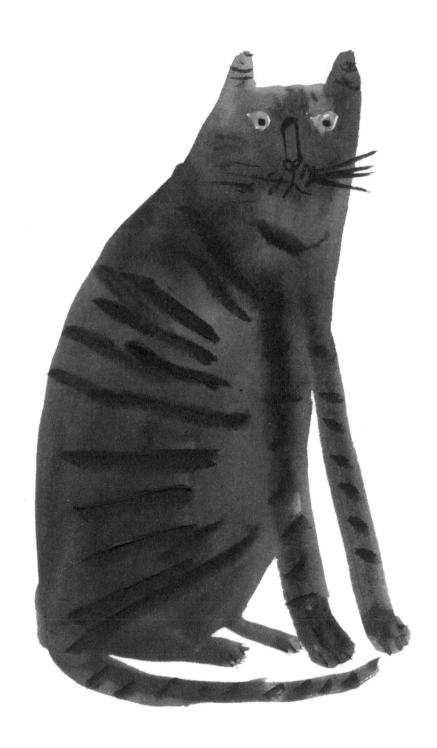

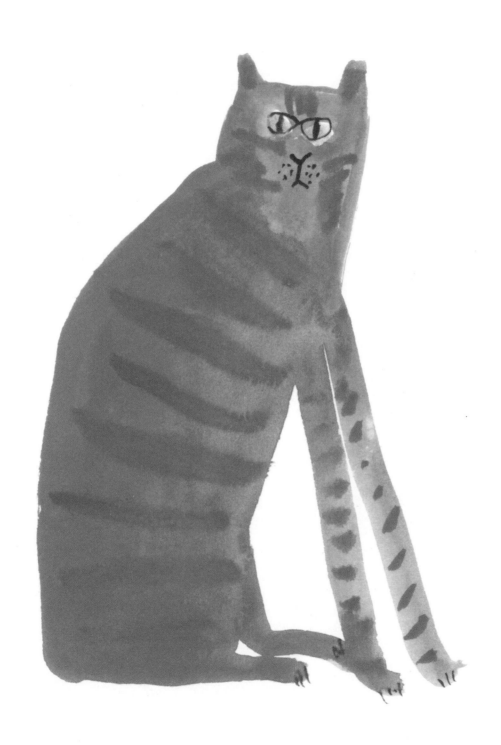

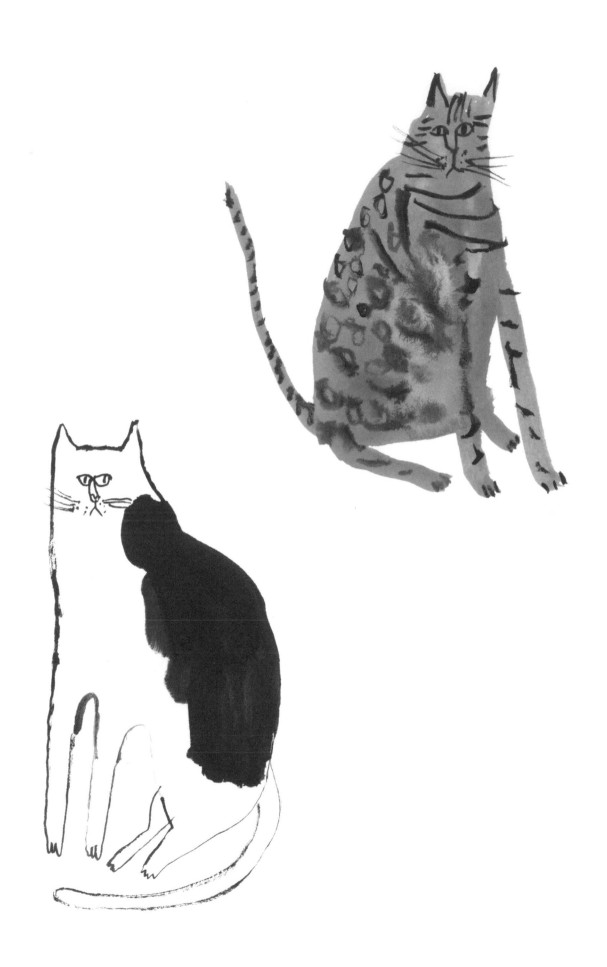

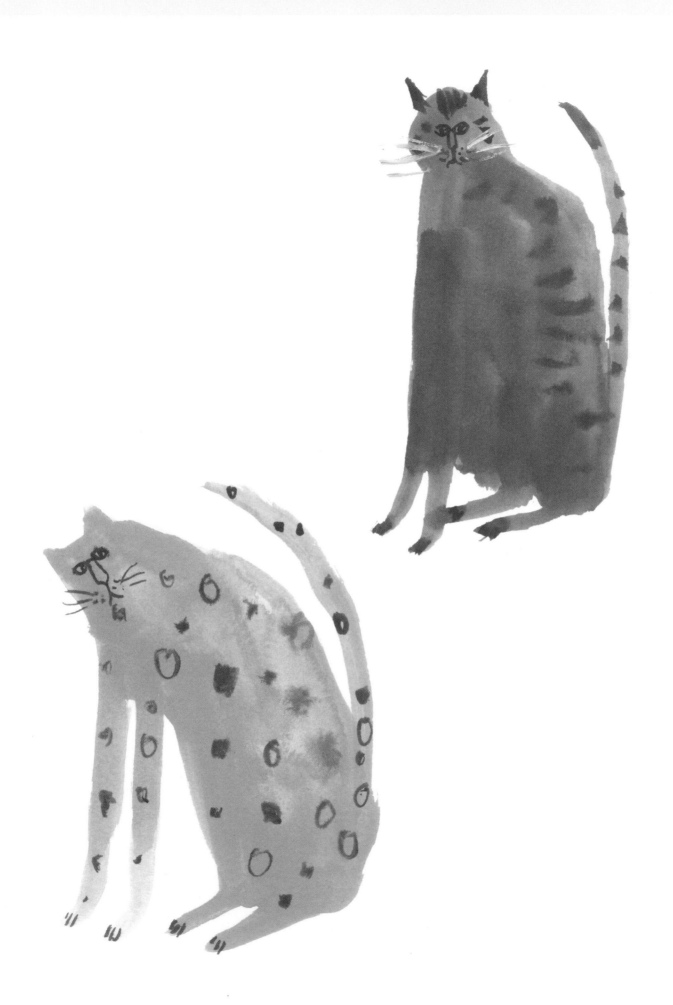

KOOKY CATS SKETCHBOOK

Use these practice areas to paint the step-by-step
projects in this section or your own favorite cats!

PICK YOUR PET

Chubby Hamster

Now let's try painting pets besides cats and dogs,
starting with this rotund little hamster!

STEP 1
Begin by mixing up a color for the hamster's
body. I used yellow ochre, white, and a
touch of red. Mix this up very loosely, and
add lots of water. This will create color and
texture when applied to the paper.

Now block in the hamster's body, which is
made up of oval shapes squished together.

STEP 2
Add white to the mixture from
step 1, and paint a long oval
shape on the hamster's head to
create the snout.

STEP 3
Mix up a pink color, and use
a fine-tipped brush to paint the
hamster's funny little hands, feet,
nose, and mouth.

STEP 4

With black paint on a fine-tipped brush, paint the hamster's eyes. Also add lines around the paws to make them stand out from the body.

Then add yellow ochre and white to the base shade you created during step 1, and paint tiny ears as well as small, messy lines on the hamster's body to suggest fur.

STEP 5

Using brown and gray colored pencils, add lots of tiny marks all over the hamster to create even more furry lines.

Goldfish in a Bowl

Dive a little deeper and create a tiny goldfish
that lives in a big bowl of water!

STEP 1

Begin by preparing your palette, and squeeze out
a little of each of the colors you will need for this
project: yellow, red, white, blue, and green.

Mix yellow with a touch of red, and use a large
brush to paint an egg shape and form the body of
the fish. Then add the fins. You can paint these as
realistically small or as comically large as you like.

STEP 2

Mix a little more red into the base
color, and use a fine-tipped brush to
paint details on the fish.

Let the other layers of
paint dry before adding the
eye, or the black paint may bleed.
If this happens, use a dry brush to
mop up the black paint, and
then add orange paint to
cover your mistake.

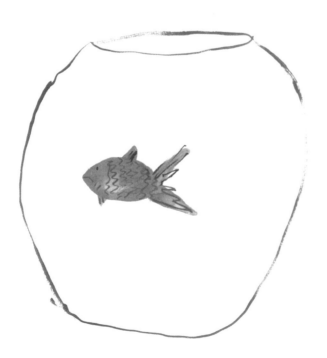

STEP 3

Add a tiny dot of black paint for the
fish's eye.

Now mix up a batch of blue, green,
and white for the water in the goldfish's
bowl. Outline the bowl with a fine-
tipped brush.

STEP 4

Use a large brush to fill in the bowl with the blue paint mixture.

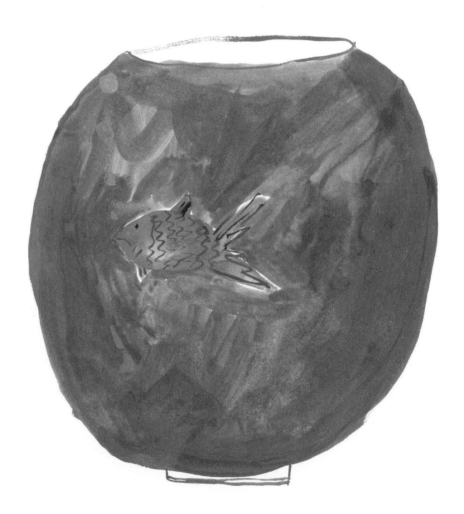

STEP 5

Add a little more white paint to the blue color, and use this to paint a few little water bubbles rising from the mouth of the fish to the surface of the water.

You can also paint a base for the bowl so that it doesn't fall over!

Miniature Pig

Mini, or micro, pigs typically weigh between 50 and 150 pounds. They're just a *tad* bigger than most of the other pets featured in this book, but they sure are cute!

STEP 1

Begin by mixing white, red, and a tiny touch of black to create a dusty pale pink shade. Then use a large brush to paint an egglike shape on your paper.

Add a little more red to the pink mixture, and paint four rectangles connected to the egg-shaped blob. These are the pig's legs!

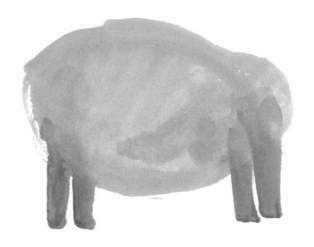

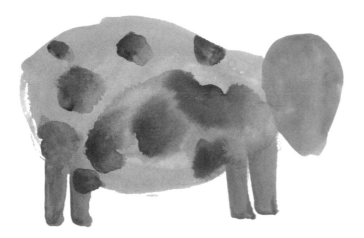

Don't panic if the colors bleed into one another here! This adds to the pig's texture.

STEP 2

While the pink paint remains wet, add dots of watered-down black paint on the pig.

Then paint an upright egg shape on the pig's body to form the head using the darker pink shade.

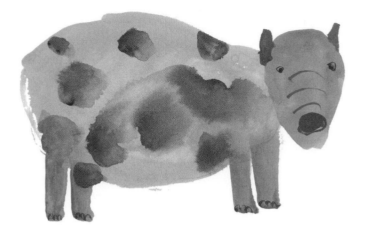

STEP 3

Add more red to the pink mixture, and use a fine-tipped brush to add triangular ears, a nose, and wrinkles to the pig.

Use a clean fine-tipped brush and black paint to create tiny beady eyes and little "M" shapes for the pig's toes.

STEP 4

Use the darker pink shade to paint a curly little tail and random lines all over the pig's body.

Then use gray and pink colored pencils to add dashes to the pig and give its body texture and depth.

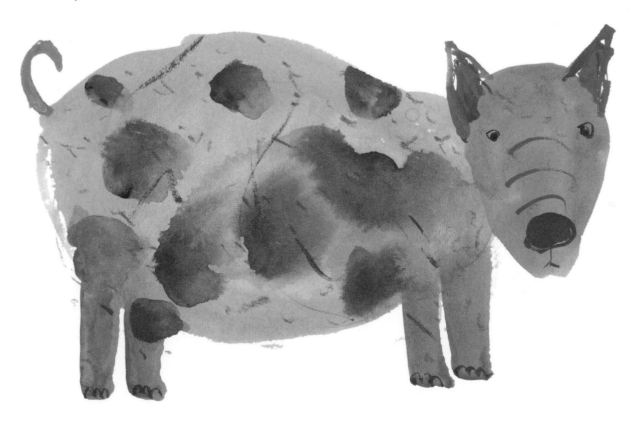

Budgie Bird Buddy

"Budgie" is a nickname for the budgerigar, or common pet parakeet. It's one of the most popular pets in the world and it can mimic human speech, so be careful what you say around your little buddy!

STEP 1
Create a yellow-green mixture, and use this and a large brush to block in the shape of the bird's body.

STEP 2
Add more green and a tiny touch of blue to the yellow-green mixture, and paint on a wing and a darker layer over the bird's tail.

Then use yellow paint and a fine-tipped brush to add a beak and little spots of color to the bird's head.

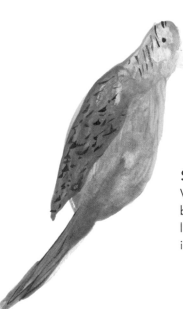

STEP 3
With black paint and a fine-tipped brush, add a tiny beady eye and quick lines throughout the bird's body. These imply feathers.

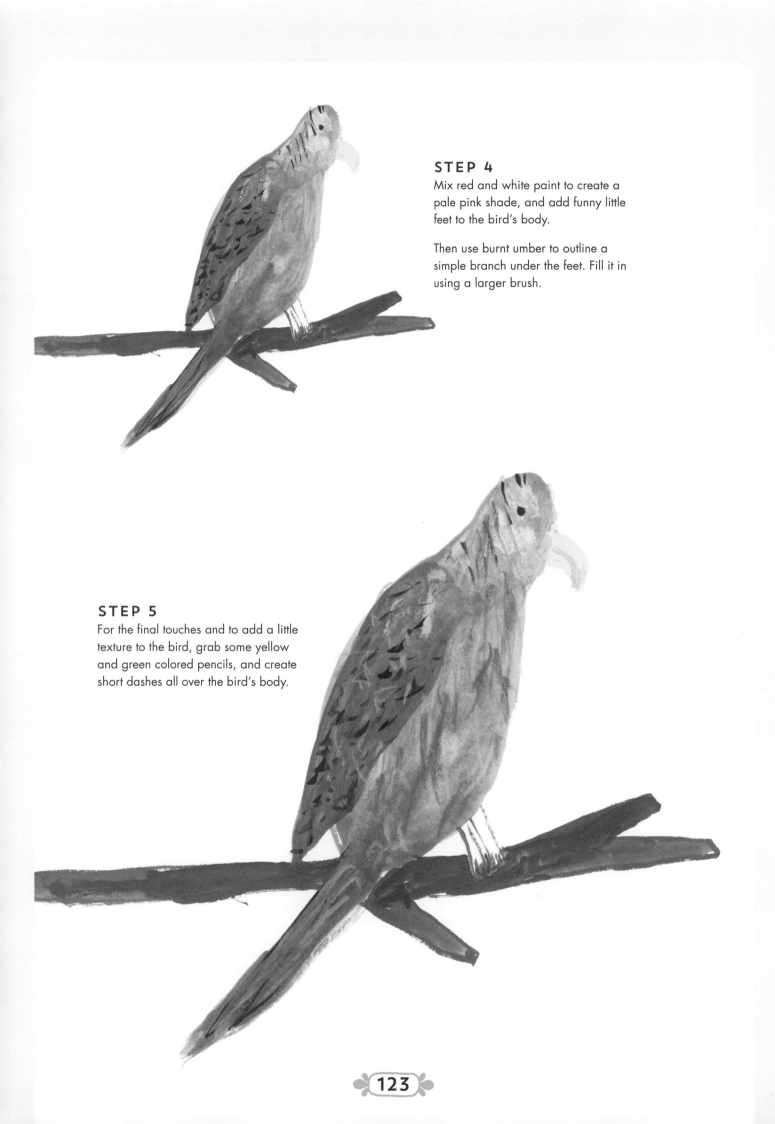

STEP 4

Mix red and white paint to create a pale pink shade, and add funny little feet to the bird's body.

Then use burnt umber to outline a simple branch under the feet. Fill it in using a larger brush.

STEP 5

For the final touches and to add a little texture to the bird, grab some yellow and green colored pencils, and create short dashes all over the bird's body.

Rascally Rabbit

This rabbit is painted a light brown and gray color, but you can use any color or combination you like. How about a white rabbit, or maybe a pink one?

STEP 1

Mix up a base color for the rabbit's body. I used burnt umber, black, and white. Then form an egg shape at an angle, the rabbit's head, and the front and hind legs, all using the same color.

STEP 2

Create an off-white color, and add a curly tail using a large brush and sweeping brushstrokes.

Mix in a touch of red, and use this pink shade to paint two tall sticks on the rabbit's head for the insides of the ears. While this paint is wet, paint around the pink ears with the gray-brown base color.

> If you're feeling lazy or in a rush, just add a tiny bit of the rabbit's base color to a smidgen of white to form the off-white color for the tail. Add water if the paint becomes difficult to mix.

STEP 3

Add more burnt umber to the base color from step 1 to form a slightly darker shade. Use a medium-sized brush to paint a long nose and lots of little strokes for the rabbit's fur.

Then use a little bit of black paint and a fine-tipped brush to add eyes, a nose, and a mouth to the rabbit.

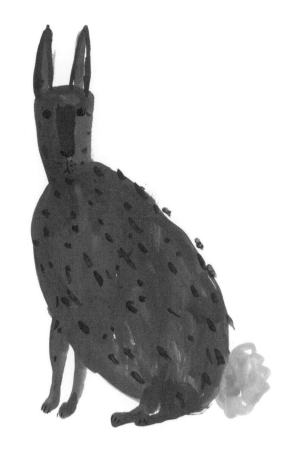

STEP 4

Clean your brush, and load it with white paint. Use this to add highlights: lots of little strokes for the fur; long, sweeping brushstrokes for the whiskers; and little white dots in the eyes.

PICK YOUR PET
SKETCHBOOK

Use these practice areas to paint your favorite kinds of animals.
Have you always dreamt of owning a chicken, perhaps, or maybe
a turtle? How about a guinea pig or a snake? Paint it here!

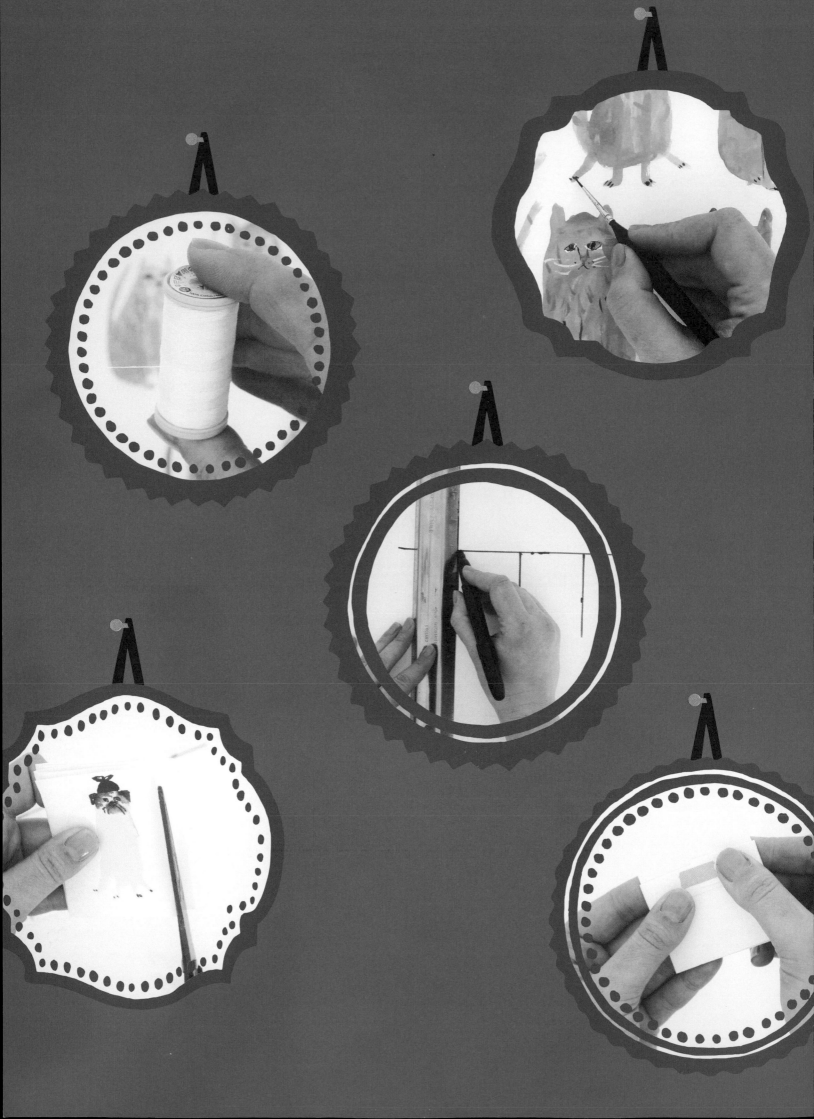

FUN
with
PAPERCRAFT
PETS

Cat Garland

This garland features a grumpy orange cat painted in gouache.
It makes the perfect addition to a bedroom or office wall,
and it's a great gift as well!

STEP 1

Begin by using gouache to paint seven orange cats onto a thick sheet of 8 ½" x 11" paper. Each cat should measure about 3 to 3½ inches in height.

Paint each cat with a different facial expression and facing in a new direction to add variety within your garland.

Allow the paint to dry.

Check out "Kooky Cats" on pages 70 through 109 for painting tips and projects! There are step-by-step instructions for painting a wide variety of cats. Feel free to personalize the ones in your garland!

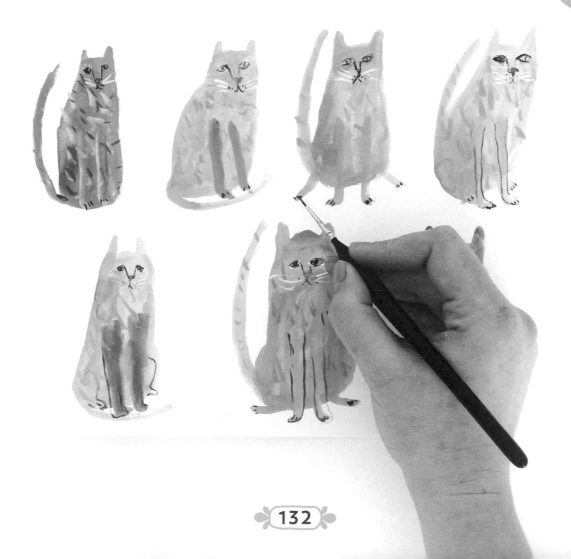

STEP 2

Use scissors to cut out each cat. Try to stick close to the shape of the cat without cutting off any tails!

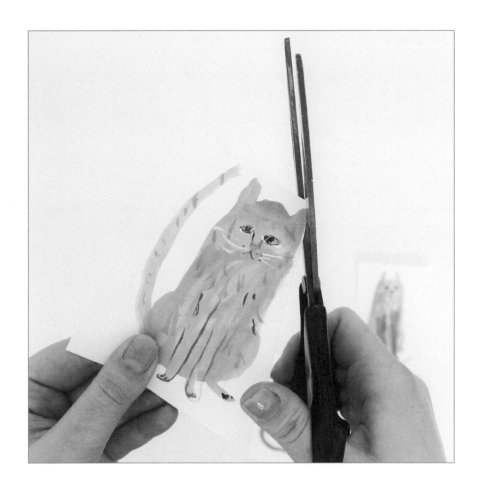

STEP 3

Measure out about 50 inches of white sewing thread. Then lay out each cat painting in the order that you want it to hang in your garland.

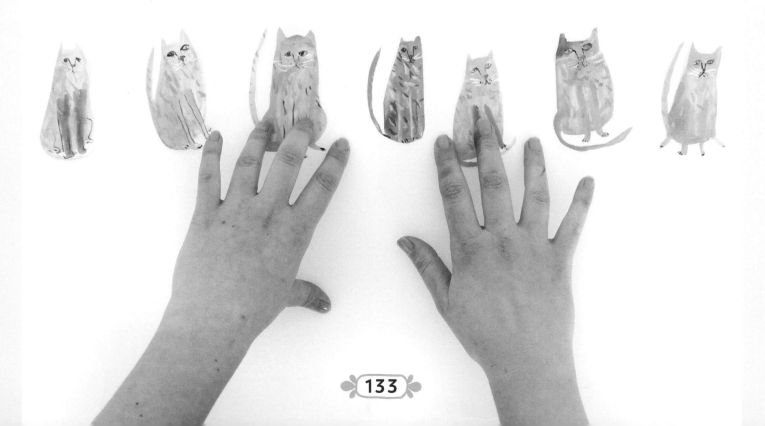

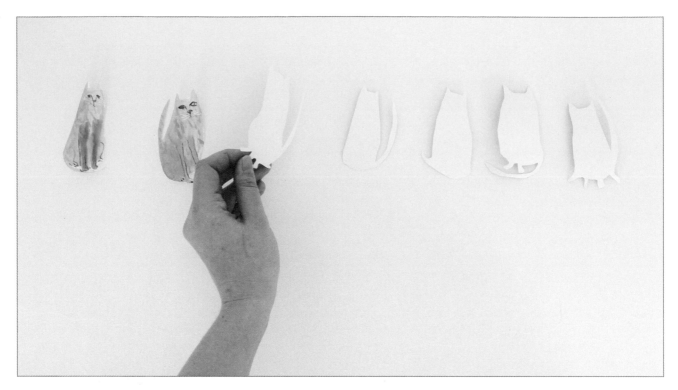

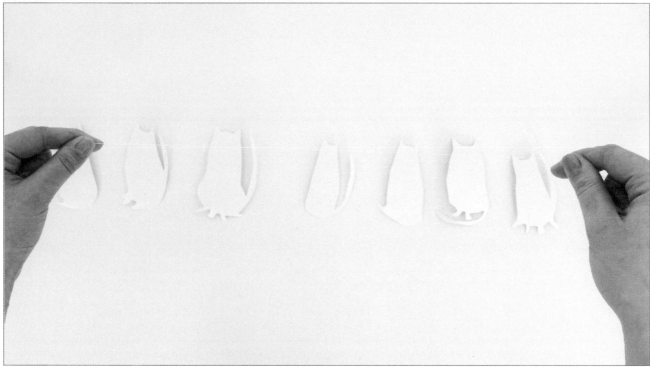

STEP 4

Now flip over each cat painting, and place the length of thread along the upside-down cats.

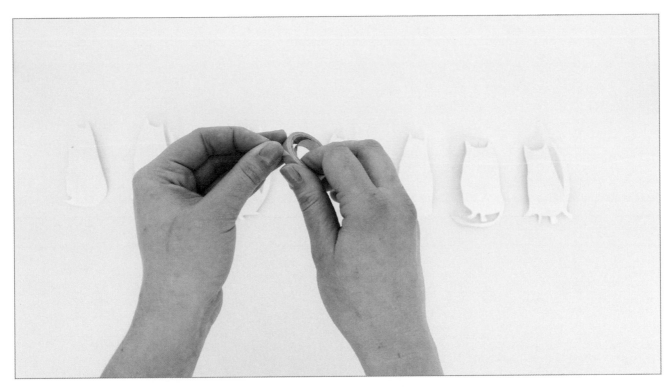

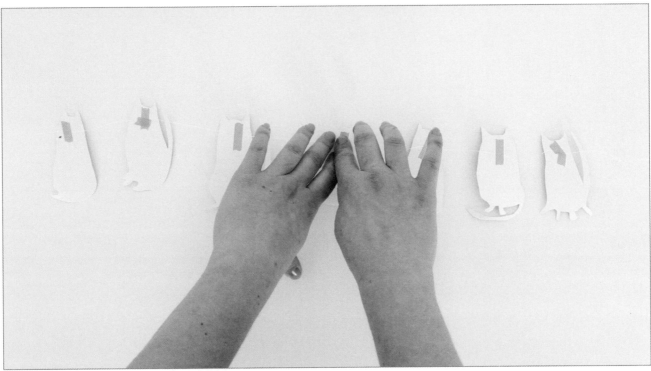

STEP 5
Tear off seven small pieces of crafting tape, such as washi tape, and secure the length of thread to your cat paintings.

Never heard of washi tape? Similar to masking tape, washi tape is durable and flexible and it doesn't leave behind a sticky residue, making it perfect for many craft projects. You can find it at craft stores and online.

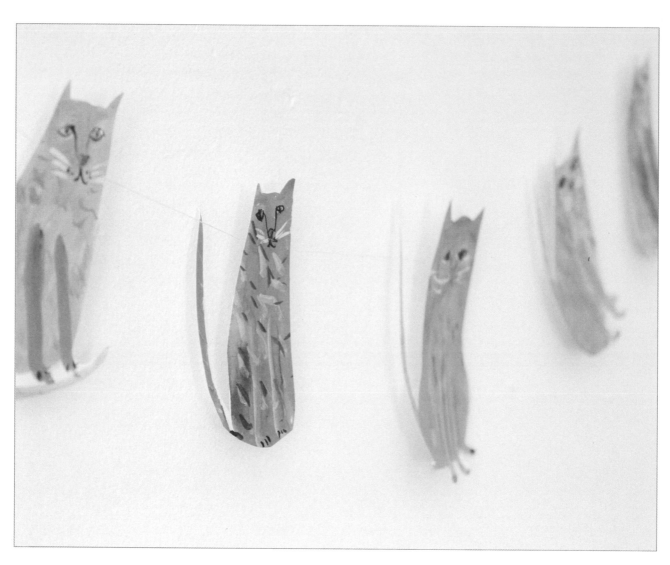

STEP 6

And you're done! Hang your beautiful, handmade cat garland on the wall of your choice, and enjoy it every day!

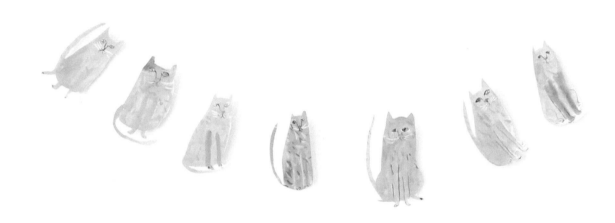

Miniature Pug Concertina Book

Now you'll learn to create a tiny book that's perfect as a gift or a keepsake to place on a shelf in your home. I used a Pug as my subject, but you should feel free to paint any cat or dog you like. Maybe you'd prefer a hamster or a goldfish? Those work great too!

• •

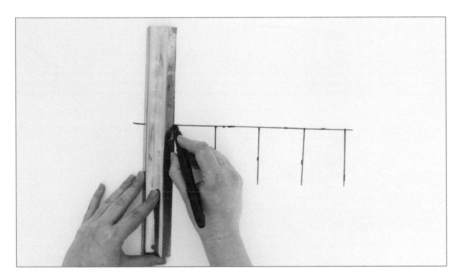

STEP 1

First, create a template on a sheet of 8½" x 11" paper.

Use a marker and a ruler to draw a horizontal line 3 inches from the bottom edge of the paper. Then draw five vertical lines 2¼ inches apart.

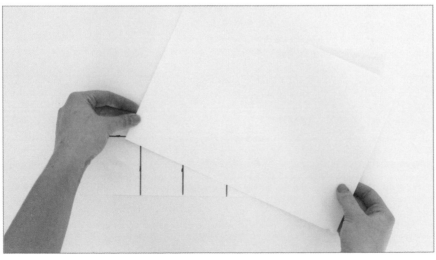

STEP 2

Place a sheet of heavyweight paper over your template so that the lines show through the top sheet of paper.

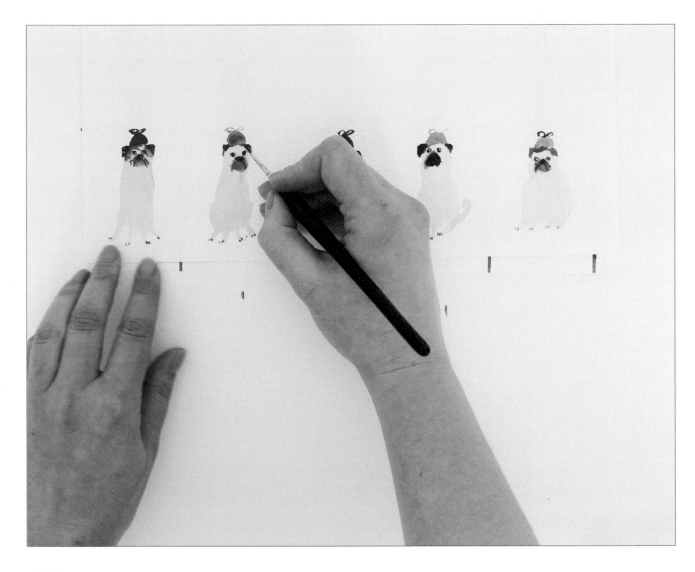

STEP 3

Use the "Pug in a Hat" project on page 32 (or another painting project of your choice!) to paint five little Pugs on the sheet of heavyweight paper. Follow the template underneath to ensure that each Pug fits within a rectangle.

Allow the paint to dry.

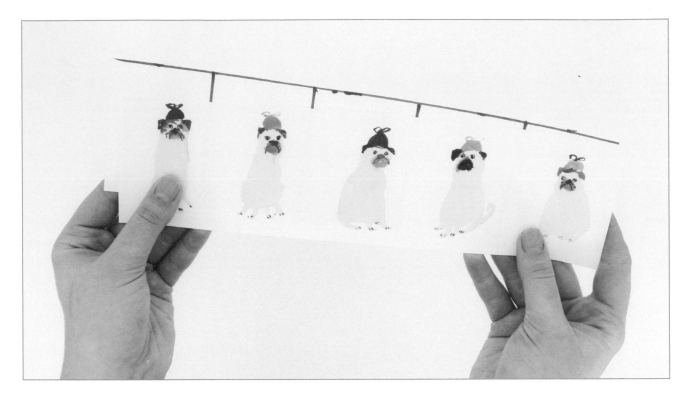

STEP 4

Now use the template to cut a rectangle around the Pugs. Hold the two sheets of paper together, and cut along the horizontal line. Also trim off a sliver of paper on the far-right side.

Don't discard the sheets of paper, as you will need them again.

I used a bone folder to press down on each fold. You can also press with your fingers or use a ruler.

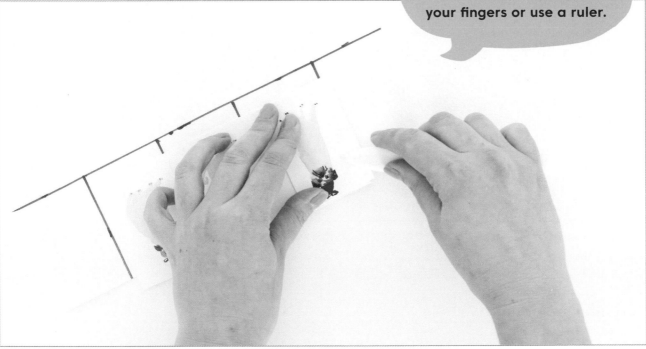

STEP 5

Using the template you created in step 1, create a crisp fold between each Pug painting. Reverse the directions of your folds so that you create a concertina-style book.

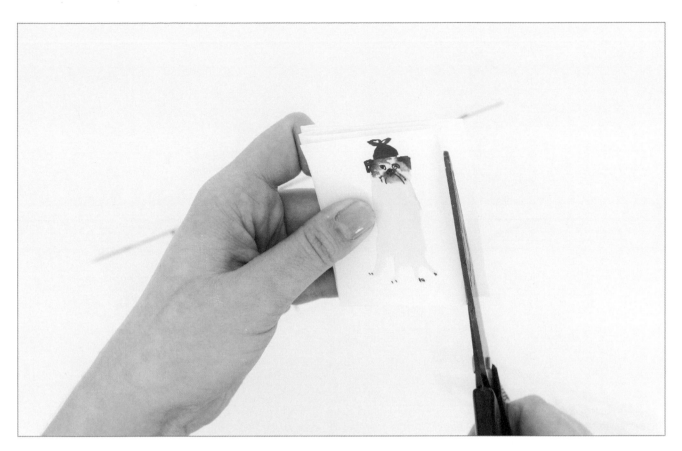

STEP 6
Use scissors to carefully trim off any excess paper from the first and last Pug paintings.

STEP 7
Now grab the sheet of heavyweight paper that you saved during step 4, and cut a ½-inch strip from it.

Wrap this strip of paper around the middle of your book.

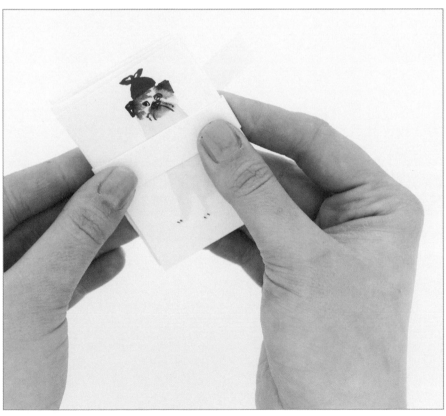

STEP 8

Trim off any excess, and secure the strip
of paper with a piece of washi tape.

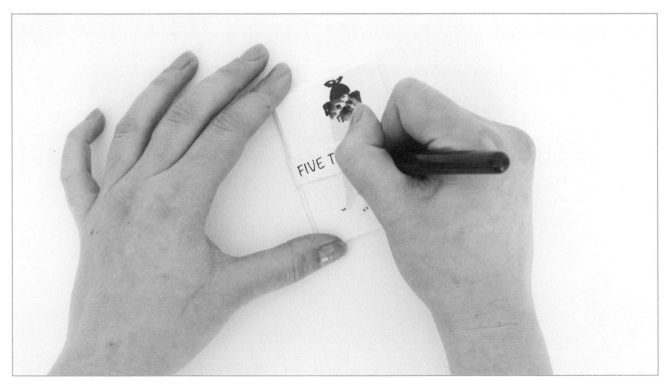

STEP 9

Flip the book over again, and write its
title onto the strip of paper.

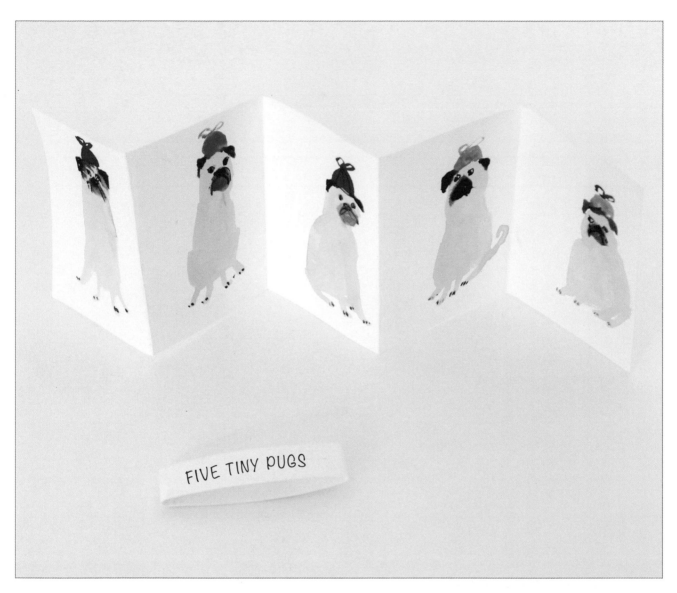

FIVE TINY PUGS

STEP 10

Now you're done! Unfold the book to enjoy each painting, or fold it up to create a tidy little keepsake item that's perfect for any dog lover.

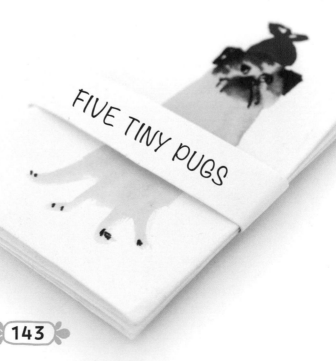

FIVE TINY PUGS

ABOUT THE AUTHOR

Faye Moorhouse is a British illustrator living and working by the sea in Hastings, United Kingdom.

She finished her degree in illustration in 2011. Currently, Faye runs a successful Etsy shop and works with clients such as *The New York Times*. Faye enjoys creating ceramics, collages, and self-published zines.